MONASTIC ICONOGRAPHY
IN FRANCE

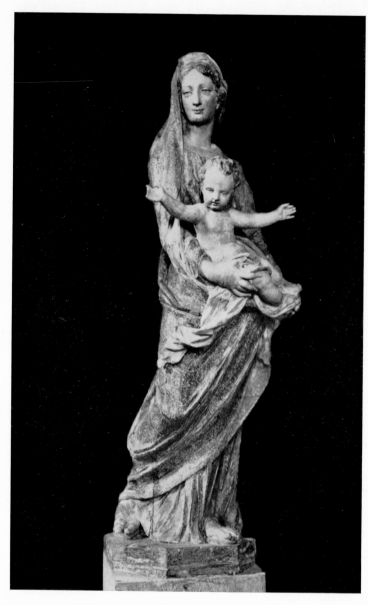

Wooden statue of Virgin and Child. (Mid seventeenth century.) From the
Benedictine abbey of Le Monastier-Saint-Chaffre, Haute-Loire.

MONASTIC ICONOGRAPHY IN FRANCE

FROM THE RENAISSANCE TO THE REVOLUTION

BY

JOAN EVANS

CAMBRIDGE

AT THE UNIVERSITY PRESS

1970

Published by the Syndics of the Cambridge University Press
Bentley House, 200 Euston Road, London N.W.1
American Branch: 32 East 57th Street, New York, N.Y. 10022

Library of Congress Catalogue Card Number: 67-12317

Standard Book Number: 521 06960 2

Printed in Great Britain
at the University Printing House, Cambridge
(Brooke Crutchley, University Printer)

To my friend George Zarnecki

CONTENTS

PREFACE

No detailed study of later monastic iconography has appeared since Emile Mâle's *L'art religieux après le Concile de Trente* was published in 1932; and that volume is not only devoted to iconography in general rather than to monastic imagery, but also, unlike his other books on religious art, is concerned primarily with Italy and Rome. In the course of a prolonged study of post-Reformation monastic architecture in France I came to realize that the religious orders in that country had characteristic iconographic preferences, and in this book I have endeavoured to set down my findings. I have not included the tombs which may be found in monastic churches since these are nearly always of laymen and in no case form part of monastic art; and I have not usually included stained glass, as being essentially medieval. I have not given the Department of the houses mentioned in the text; it will be found in the Index and in the List of Plates

I am greatly indebted to my friends Mr and Mrs Dyneley Hussey, Madame Claude Carnot, Mademoiselle Marguérite Prinet and Dr George Zarnecki for their kindness in taking me to see many of the monasteries and galleries in question; to the latter and Madame Fourès for allowing me to reproduce photographs of their taking; and to Monsieur Jacques Dupont for permitting me to illustrate a sculpture by Michel Anguier in his collection. Miss Vera Dallas has undertaken the laborious task of compiling the index.

Wotton-under-Edge J. E.

February 1969

ACKNOWLEDGEMENTS

Permission to use illustrations is gratefully acknowledged to owners of the copyrights as follows: Éditions Margerit-Brémond, Le Puy: frontispiece; Archives Photographiques, Paris: 1, 11, 15, 18, 21, 22, 25, 27, 34, 36, 40, 45 *a*, 46, 47, 67, 68, 69, 77, 89, 97, 108, 111, 113, 116; Courtauld Institute of Art, London: 2, 6, 17, 29, 35, 37, 45 *b*, 90, 107; Archives du Touring Club de France: 4, 56; Musée de Rennes: 5; Arts Graphiques de la Cité, Paris: 7, 39, 73, 102; J. Camponogara, Lyon: 9, 74; M. Jacques Dupont: 10; Giraudon, Paris: 12, 14, 23, 48, 86, 100, 112; Renault, Valenciennes: 16; Royal Academy of Arts, London: 19, 38, 43, 44, 52, 63, 85, 98, 101, 109, 114; L'Abbaye Notre Dame de Jouarre, Seine et Marne: 20; Éditions d'Art JOS, Finisterre: 24; Éditions G d'O, Puy de Dôme: 26; Dr G. Zarnecki: 28, 32, 60, 80; R. Remy, Dijon: 30, 94; Musée de Dijon: 49, 50, 62, 64, 103; Éditions Alex Bernard, Nancy: 33; Ellebé, Rouen: 41, 72, 110; Musée d'Alençon: 42; Camille Gonnard, Moulins: 51; Musée de Grenoble: 53; Editions Drouhin, Paris: 54, 84; Musée de Chartres: 55; R. Sallis, Narbonne: 57, 88; Union des Musées Nationaux: 58, 59; L. Borel, Marseille: 65, 66; Photo-Rex, Toulouse: 70, 82, 83, 99; Photographie Monique Porée: 71; Egea et Gaymond, Villeurbanne: 76; Salomone, Roma: 78; Photo Daspet, Villeneuve les Avignon: 79; Compagnie des Arts Photomechaniques, Paris: 81; Éditions Bulloz, Paris: 87; Éditions d'Art 'B.L.', Lagnieu: 91; Éditions Provençales, Nice: 92, 93; Armen, Nantes: 95; Musée des Beaux Arts, Nantes: 96; Musée des Augustins, Toulouse: 104; Studio Piccardy, Grenoble, 105, 115; The Trustees of the National Gallery, London: 106

PLATES

44 Mère Agnès. Philippe de Champaigne, 1662. From the Cistercian nunnery of Port-Royal. Now in the Louvre.

45 Cistercian abbey of Valloires, Somme, c. 1765. (a) The high altar. (b) Angels above the high altar.

46 Cistercian abbey of Valloires, Somme. Retable of the apse, c. 1765.

47 Cistercian abbey of Valloires, Somme. Side chapel, c. 1765.

48 Our Lady of Sorrows, given to the Augustinian abbey of Sainte-Geneviève, Paris, by Juste de Serres, Bishop of Le Puy, Germain Pilon c. 1600. Now in the Louvre.

49 Baptism of St Augustine. Louis de Boullogne [1654–1733]. Now in the Musée de Dijon.

50 Consecration of St Augustine. Louis de Boullogne. Now in the Musée de Dijon.

51 St Augustine washing the feet of the Pilgrim Christ. From an Augustinian house. Now in the Musée de Moulins.

52 St Nicholas of Tolentino and angels. Ambroise Frédeau, 1650. From the sacristy, Saint-Augustin, Toulouse. Now in the Musée des Augustins, Toulouse.

53 St Nicholas of Tolentino giving alms. Claude Guy Hallé [1652–1736]. From an Augustinian house. Now in the Musée de Grenoble.

54 High altar, Grands-Augustins, Paris. After Millin.

55 Louise de Pardaillan de Gondrin, last abbess of Fontevrault, c. 1775. Now in the Musée de l'Ancien Evêché, Chartres.

56 Premonstratensian abbey of Mondaye, Calvados. Retable in chapel of the Virgin. Melchior Verly, c. 1745.

57 Sisters of Charity, presenting orphans to St Vincent de Paul Jacques. Gamelin, 1786. From the house of the Sisters of Charity, Narbonne. Now in the Musée de Narbonne.

58 Sisters of Nôtre Dame de la Charité adoring the Sacred Hearts of Jesus and Mary. Jean Lamy, 1735. From the convent of the Dames de la Charité du Refuge, Tours. Now in the Musée des Beaux Arts, Tours.

59 Assumption of the Virgin. Charles Lamy, 1734. From the convent of the Dames de la Charité du Refuge, Tours. Now in the Musée des Beaux Arts, Tours.

60 Chapel of the Dames de la Charité du Refuge, Besançon. High altar.

61 Ursuline convent, Auxerre, Yonne. Relief over chapel door, c. 1580.

62 Presentation of the Virgin in the Temple. Jean Tassel, 1648. From the Ursuline convent, Dijon. Now in the Musée de Dijon.

63 Coronation of the Virgin. Jean Tassel, 1648. From the Ursuline convent, Dijon. Now in the Musée de Dijon.

64 Portrait of Cathérine de Montholon. Jean Tassel, c. 1650. From the Ursuline convent, Dijon. Now in the Musée de Dijon.

65 Visitation. François Puget, c. 1680. From the Visitandine convent, Marseilles. Now in the Musée de Marseilles.

66 Coronation of the Virgin. Pierre Parrocel, c. 1690. From the Visitandine convent, Marseilles. Now in the Musée de Marseille.

67 Death of St Bruno. Le Sueur, 1645–8. From the Lesser Cloister, Charterhouse of Paris. Now in the Louvre.

68 St Bruno in prayer. Le Sueur, 1645–8. From the Lesser Cloister, Charterhouse of Paris. Now in the Louvre.

INTRODUCTION

Monastic communities after the Reformation drew inspiration in full measure from the common fount of religious iconography. The heretics' contempt for images made Catholics revere them the more; the heretics' ignorance of the lives of the saints made them the more significant. It is impossible (as Emile Mâle has pointed out[1]) to exaggerate the distress of the true Catholic at the apostasy of the Protestants, and this distress was most acutely felt among those vowed to the religious life. They saw the Virgin insulted, the Mass dishonoured, and the pictures and images that were the concrete expression of their faith deliberately defaced, cast down and destroyed. Yet it was in consequence of the Protestant attitude that the Catholic hierarchy began to look critically at the images and pictures in their churches. The result was a most intellectual and reasonable iconography; it included few apocalyptic visions, except of the most traditional kind; even the Last Judgment went out of fashion. There is a large cohort of local saints, of the most respectable ancestry, who are not represented in monastic iconography after the Council of Trent.

In the years when the religious wars were not raging, it is not unusual to find Huguenot artists working for the church. Jean Giffard of Angers, who carved Maurice and his companions for the tower of Saint-Maurice in 1537 and the death of the Virgin for the Hôtel-Dieu in 1556, was hanged as a Huguenot in 1562, a stone's throw from the building he had adorned. Later, too, a few Calvinist artists, such as Sébastien Bourdon, occasionally painted church pictures.[2]

At the twenty-fifth and last session of the Council of Trent an ordinance was passed forbidding that any image should be set up in church that was inspired by an erroneous doctrine or that might lead ignorant men astray. The Councillors even went so far as to forbid any unusual image, unless it had previously been approved by the bishop. Nudity, that had begun to creep in with Renaissance paintings, was forbidden, and various details of iconography were proscribed.

The monasteries had less need to be concerned than the cathedrals and parish churches with the impact of their art on ignorant congregations; in their iconography, as in their architecture, the transition from the fashions of the middle ages to those of the Renaissance was slow and gradual. None the less, one of the earliest representations of the Immaculate Conception in France occurs on a sixteenth-century retable at the Cluniac house of Souvigny.

The creation of a post-Tridentine iconography was, indeed, in general both

[1] *L'Art religieux après le Concile de Trente* (1932), hereafter referred to as *A.R.C.T.*
[2] Mâle, *A.R.C.T.* p. 13.

slow and hesitant. The negative advice which was all that the Council offered could hardly inspire an art; and in fact the influence of the Council on art was unexpectedly limited. Books such as Molanus' *De picturis et imaginibus sacris*, published at Louvain in 1570, which derived their impulse from the decrees of the Council, were occupied in defending the accepted Catholic iconography and in purifying its tradition rather than in counselling anything new.[1] In fact the ecclesiastical censors were chiefly occupied with such points of detail as that the Virgin should not be portrayed fainting at the Crucifixion, since '*stabat* Mater'.[2] Yet in France both Simon Vouet and François Perrier painted fainting Virgins.

The pictorial art of the Counter-Reformation has been ably studied by Emile Mâle. He has stressed[3] the importance of the excavations of Bosio in the Catacombs, beginning in 1593, and the posthumous publication of his *Roma sotteranea* in 1634, in stimulating interest in the saints and martyrs of the early Church. This interest, indeed, seems to have exercised a wider stimulation; the men who for the first time saw the simple graves and monuments of early saints turned with fresh eyes to look on the great men of their fathers' and their own generations. No canonization was effected in Rome from the papacy of Adrian VI to that of Sixtus V, from 1522 to 1585. Then in 1588 the Franciscan San Diego was canonized, the first of a long series of new saints of whom by far the greater number were directly connected with a monastic or mendicant or preaching order, old or new. Such canonizations were accompanied by a corresponding number of lives of saints, often personal and documented biographies.[4] The monasteries these saints had served often owned their portraits, and the ceremonies of their canonization were beautified by painted banners and pictures of them, and of events in their lives, that were hung for a time in St Peter's.[5] From these literary and pictorial sources a whole new iconography grew up, supplemented by developments in the received iconography of the older monastic saints. Ecstasy, it has been said,[6] only appears in art with the Counter-Reformation: and it might be added that it first appeared in the pictures of the religious Orders.

The multiplication of pictures in churches helped to create specialists in the *genre*. Some, like the seventeenth-century painter Jean Boucher of Bourges,[7] remained constant to ecclesiastical patronage. He had his atelier in one of the towers of the cathedral and only worked for churches and religious houses; in his will he asks for their prayers. He painted himself with his mother at the feet of his patron saint, with the inscription: 'Grand saint, reçois le cœur de Boucher pour offrande.'

[1] A later book, *Les emblèmes eucharistiques*, published in 1647 by Dom A. Belin, a monk of La Charité at Nevers, has no pictures, and is composed of little sermons that have nothing to do with visual art. The Abbé Méry's *Théologie des peintres*, published in 1765, seems to have been intended for parochial rather than monastic use.

[2] Mâle, *A.R.C.T.* p. 8. [3] Mâle, *A.R.C.T.* p. 123.

[4] See Brémond, *Histoire littéraire du sentiment religieux en France*, I, 238.

[5] Mâle, *A.R.C.T.* p. 98. [6] *Ibid.* p. 157. [7] Chennevières, II, 116.

INTRODUCTION

Far more often church painting was but a stage in a career. The study of such biographies of artists as those furnished by Guillet de Saint Georges reveals a recognizable pattern. The artist, often the son of another, works at home until he somehow gets money to go to Rome. After a few years in that city, he returns to France, and works for the churches, and most often for the churches of the religious Orders. Poussin, for example, in his early days worked for the Capuchins of Blois and the Jesuits of Paris; Le Sueur for the Benedictines, Carthusians, Capuchins and Oratorians; and Jean-Baptiste Oudry for Saint-Martin-des-Champs. Then, and then only, if he is successful, he works for private patrons and, if he is fortunate, for the King. Many second-rate artists, such as Nicolas de Plate Montagne, Claude Vignon, Jean Jouvenet, the Parrocels, remain primarily church painters; and better painters, such as Le Sueur and Vouet, cannot be fully appreciated without a study of their ecclesiastical painting.

By the middle of the eighteenth century the pattern was beginning to change: artists were discovering that the Church paid badly. An article on Louis Galloche by Louis Gourgenot, published in 1767,[1] explains his difficulties in restoring his fortunes after he had lost money in speculation.

Les tableaux d'église, qui faisoient la principale occupation de M. Galloche, étoient peu propices à réparer ses pertes. Nous ne pouvons nous dispenser de le dire à l'honneur des artistes et à la honte de ceux qui font travailler pour les lieux saints. Ces sortes d'ouvrages sont toujours payés à vil prix, en comparaison des tableaux dont les sujets sont profanes. On sait cependant que les peintres font d'autant plus d'efforts pour les amener à leur perfection, qu'étant destinés à rester sans cesse sous les yeux du public, ils leur procurent les moyens les plus sûrs d'établir ou d'affermer leur réputation et de faire passer leurs noms à la posterité.

[1] Guillet de Saint Georges, Mémoires inédits, II, 296.

1

THE BENEDICTINES

The Benedictines had created a strong iconographic tradition in the Romanesque period.[1] It continued through the later middle ages, though diluted from the common stream of religious sentiment and, in the latest period, modified by the common use of devotional and illustrative engravings as models.

It is fair to say, indeed, that by the beginning of the sixteenth century the existence of a characteristic Benedictine iconography had been almost forgotten. Such works as the triptych of the Passion given to the Cluniac house of Ambierle by Michel de Changny in 1470 find a parallel in the chapels of the Duke of Burgundy rather than in earlier Benedictine churches. The early sixteenth-century statues, rich and dumpy, in the chapel of St Angilbert at Saint-Riquier are characteristic of the Amiens school rather than of any specially Benedictine interests; among St Veronica, St Helena, and the local saints St Vigor and St Riquier, only St Benedict (in a very ample habit) has any special monastic significance. The façade of the Saint-Riquier Trésorerie has three statues of saints—St Anthony, St Sebastian and St Roch—chosen because they protected men from plague, not for any Benedictine appropriateness.[2] The chapel of the Virgin was painted with a large collection of women saints; and among the statues in the chapel of St Peter no monk was represented. Instead it held statues of the risen Christ; of St Peter as pope and St Riquier as bishop; of St Thibault (given by the abbot, Thibaut de Bayencourt) and of St James as a pilgrim. In the chapel of St-Marcou the saint appeared in Benedictine habit but was accompanied by St Riquier as a prince, St Barbara and St Andrew.

The introduction of Renaissance style was in itself so exciting that at first little was done to make its iconography appropriate, provided only that it was classical. The façade of the Benedictine abbey of Saint-Michel at Dijon, which seems to have been begun about 1530, has the coffered decoration of its arcades filled with reliefs that seem to be taken straight from engravings: Minerva, Apollo and Venus consort with Solomon and Judith. The chapel of Saint-Chaffre at Le Monastier has a remarkably ugly Renaissance ceiling of which the cofferings are entirely filled with secular subjects. Exceptionally, at the Benedictine priory of Saint-Florentin, one lateral façade, dated 1611–13 but earlier in style, has statues of Moses and Aaron on either side of the door.

Soon after 1507 Antoine Bohier, abbot of La Trinité at Fécamp, acquired from

[1] See Mâle, *L'art religieux en France au XIIe siècle* (Paris, 1922); Joan Evans, *Romanesque art of the Order of Cluny* (Cambridge, 1938).

[2] The sixteenth-century wall-paintings inside the treasury were of the Three Living and the Three Dead and of the recovery of the body of St Riquier by Hugues Capet.

Pace Gaggini of Genoa a tabernacle to enshrine the relic of the Precious Blood (Plate 1). Though entirely Italianate in style, its iconography is traditional and medieval; God the Father holding the world, the Annunciation, the Resurrection, and the Evangelists.

Often, too, when the piety of patron or donor introduced a medieval subject, little was done to integrate it into the Renaissance scheme. The Lady Chapel of the Benedictine abbey of Valmont, near Fécamp, was rebuilt by the Estouteville family between 1517 and 1552. Its splendid vaulting is late Gothic, but the columns and friezes and all the ornament are classical. Yet a medieval God the Father rises from a classical garland (Plate 2) and a traditional group of the Education of the Virgin fills the spandrel of a classical arcade.

The normal sculptural contribution of the late fifteenth century or the early sixteenth to a monastic church was an Entombment group[1] that might equally well have figured in a parish church. The fine Descent from the Cross at Gournay, by a sculptor of the school of Pilon, would be equally appropriate to any Christian church, as would the group of the Annunciation of the same school in the Lady Chapel at Valmont.[2] The relief (Plate 3) of Christ and the woman of Samaria at the well that delightfully adorns the fountain at Saint-Seine-l'Abbaye is appropriate to its position, but would serve for any spring. Most unusually, the chapel of Notre Dame de la Pitié in the Cluniac house of Saint-Sauveur de Figeac holds a seventeenth-century panel of the Christ Child sleeping on a Cross.[3]

Far more often the pictures in Benedictine churches continued to be those of the accepted Catholic iconography,[4] chosen without special appropriateness: the Annunciation,[5] Joseph's Dream, the Nativity, the Adoration of the Magi,[6] the Circumcision,[7] the Presentation in the Temple,[8] and the Flight into Egypt[9] cover the childhood of Christ. Scenes from his life,[10] and especially his miracles, are

[1] E.g. Solesmes and Carennac. A later one at Saint-Serge d'Angers, made by Gervais Delabarre in 1593, is no less medieval in spirit.

[2] So too is the triptych from Gimont now in the parish church there.

[3] Réau, II, 2, p. 286.

[4] Unusual subjects rarely appeared in the church itself. At Saint-Germain-des-Prés Le Brun's Cain and Abel was hung in the Library (Jouin, p. 463), and a picture of St Philip baptizing the eunuch of Queen Candace in the sacristy.

[5] Marmoutier, by Le Sueur.

[6] Saint-Martin-des-Champs, an early work of J. B. Oudry, Guillet de Saint Georges, II, 385; Saint-Victor by Claude Vignon, ibid. I, 275; Saint-Trophime d'Arles, Pointel and Montaiglon, Quelques peintres provinciaux, I, 25.

[7] E.g. picture in the church of the Benedictine abbey of Massay, Cher.

[8] Saint-Martin-des-Champs, by Claude Vignon, Guillet de Saint Georges, I, 275; Saint-Victor, now in Saint-Nicolas-du-Chardonnet (and see Derel, p. 159).

[9] La Merci du Marais, by Boullogne, now in the Louvre; Toulouse, now in the Toulouse Museum.

[10] Two pictures of Pilate washing his hands, and one of Christ bearing the cross, by J. F. de Troy, were at the Benedictine nunnery of Ville-l'Evêque (Guillet de Saint Georges, II, 276). The Samaritan woman and the Canaanite woman were portrayed at Saint-Martin-des-Champs (ibid. I, 352); the Sermon on the Mount at Saint-Martin-des-Champs (Piganiol de la Force, IV, 34). The Baptism of Christ appears on a retable at La Chaise-Dieu. The Baptism and Christ teaching little children were painted by Lépicié in 1765 for the refectory of the Abbaye-aux-Hommes at Caen.

popular subjects:[1] the Crucifixion,[2] the Last Supper, the Descent from the Cross,[3] Pentecost,[4] or the Transfiguration[5] were in every church and the Assumption[6] and Coronation of the Virgin were frequently to be found, especially in houses dedicated to Our Lady.[7] Even when they were not so dedicated, a Lady Chapel was often specially adorned; for example the north absidiole of the Cluniac priory of Pommiers-en-Forez has a set of Italianate wall-paintings of the early sixteenth century devoted to the life of the Virgin. A particularly splendid relief of the Assumption adorns the high altar in her nunnery at Guebwiller (Plate 4). The Dominican subject of the Institution of the Rosary was in 1624 represented in the church of the Benedictine nuns of Notre-Dame-du-Pré at Le Mans.[8] The Magdalen (whom Brémond describes[9] as the favourite heroine of the seventeenth century) was portrayed in many monasteries[10] (Plate 5). St Peter and St Paul[11] were well represented: by statues on either side of the tabernacle of the high altar at Saint-Pierre de Rheims;[12] in a splendid missal cover at Saint-Riquier (Plate 6); in ten paintings in the nave of Saint-Germain-des-Prés[13] (Plate 7); and in a series at Saint-Pierre-les-Dames at Rheims, by Jean Hellart.[14] Christ giving Peter the keys is carved on a fine gilt-wood retable (Plate 8) in the transept of the Cluniac priory of Beaulieu, which was dedicated to him and to St Paul. When, about 1669, the

[1] E.g. Saint-Martin-des-Champs, pictures by Jean Jouvenet of 1706 of the Miraculous Draught of Fishes; Piganiol de la Force, IV, 32, 34, Blunt, p. 274; the Resurrection of Lazarus and Christ driving the money-changers from the Temple; they are now in the Louvre (433 and 434). These subjects were also woven at the Gobelins after 1711.

[2] E.g. by Besnard, 1662, at Notre-Dame-de-la-Couture, Le Mans; retable at La Chaise-Dieu; retable, 1694, by Pierre Barauden (and another of the Adoration of the Shepherds) at Fontaine Couverte, Mayenne, which depended on the Abbey of Lalöe. See V. Tapié, *The age of grandeur* (1960), figs. 108 and 109.

[3] E.g. retable at La Chaise-Dieu.

[4] E.g. by Jouvenet, at Notre-Dame-de-la-Couture, Le Mans.

[5] E.g. J. B. de Champaigne's of 1677 from the high altar of Saint-Thierry-de-Reims, now in the Rheims Museum.

[6] E.g. that painted by Nicolas de Plate Montagne for the high altar of the Abbaye du Chage at Meaux, Guillet de Saint Georges, I, 352.

[7] La Riche, by Charles Lamy, now in Tours Museum, no. 105: ceiling of the Lady Chapel, Saint-Germain-des-Prés, by Le Nain (it has disappeared); Abbey of La Charte, Meaux, by Nicolas de Plate Montagne, Guillet de Saint Georges, I, 352; and any number of sculptured retables, e.g. that at Beaulieu, Corrèze, flanked by statues of St Joseph and St Anne. At Pontlevoy a bas-relief of the Dormition of the Virgin by Antoine Charpentier, 1651, is noteworthy as portraying Our Lady dying seated.

[8] Still in the church.

[9] I, 383.

[10] E.g. in a statue at Sainte-Croix-de-Bordeaux and in pictures at Saint-Melaine, Rennes, by P. de Champaigne (now in Rennes Museum) and another from the Val-de-Grâce now in the Louvre; Saint-Martin-des-Champs, by Jean Jouvenet, Guillet de Saint Georges, II, 26.

[11] A picture of the Vision of St Paul on the road to Damascus from Bernay is now no. 27 in the local Museum; another of the Saint and Ananias, by Jean Restout, 1709, from Saint-Germain-des-Prés, is in the Louvre. A picture of the Conversion of St Paul at the Abbaye aux Hommes at Caen, now attributed to Dom Fournier, may be that exhibited by Lepicié at the Salon of 1767. See Diderot, *Salons*, ed. Seznec and Adhémar, III (1963), 36.

[12] By Thibaut Poissant, *c.* 1560, Guillet de Saint Georges, I, 322.

[13] Piganiol de la Force, VIII, 17; they were by various painters.

[14] Some of them are now in the Rheims Museum, nos. 268-70.

abbess of Saint-Pierre de Lyon wished to adorn her renovated church with pictures of the life of its patron saint, she only allowed her painter, Thomas Blanchet, to proceed after she had approved every detail of his scheme,[1] and of the sculptured emblems that adorned the church. For her own oratory she chose a sculptured Descent from the Cross, and a row of busts of the abbey's royal benefactors.

The refectory at St Pierre (Plate 9) was designed as a double cube, with seven great windows and a marble floor. It has a dado of heavily moulded panelling, a rich ceiling in which three pictures are inset, and great pictures to fill the wall at either end. The spaces between the windows, and the places above the dado whence rise the arches of the roof, are filled with stucco figures of the monastic virtues; like those in the nuns' choir at the Val-de-Grâce, they are drawn from Cesare Ripa's *Iconologia*. Simon Guillaume added to them only too many additional statues which form no part of the original scheme: St Benedict at Subiaco; Simon, Mary Magdalene, St John the Evangelist, the Baptism of Christ, St Anthony, St Ennemond, St Catherine, St Barbara; a bas-relief of the Virgin; busts of Esther, Judith, Deborah and the mother of the Maccabees; figures of Charity, Modesty, Penitence and Temperance, and five geniuses bearing cartouches of the arms of the abbess.

The cloister had statues of St Michael and St Gabriel in niches, and a central fountain. A staircase rises from each walk of the cloister; the main one has three flights of marble stairs, with a marble balustrade. It was originally adorned with the statue of Virtue (with the arms of Chaulnes) and statues of the Wise Virgins in the angles. The door on the landing was ornamented with a figure of Charity, and the Corinthian cornice with Virtues and Renowns. The chapter-house, with elaborate panelling, held statues of Wisdom, Reform, Sincerity, Penitence, Humility and Silence. None of them remain.

The noble church originally had four statues, nearly life-size, of the Cardinal Virtues, and two of angels holding candlesticks; a grotto in the apse held a figure of St Peter in chains.[2] The high altar, of coloured marbles, set up in 1681, had a silver relief in front, over five feet long, of the Adoration of the Shepherds. The bronze tabernacle was adorned with silver figures of children; its silver door was chased with the angel appearing to St Peter.

Exceptionally, the great royal rebuilding of the Benedictine nunnery of the Val-de-Grâce at Paris gave scope to an entire scheme based on the iconography of Our Lady. In 1638 Anne of Austria decided on the benefaction in gratitude for the birth of the Dauphin—Louis XIV—after twenty years of married life. The ancient monastery had borne the name of Le Val-de-Grâce de Notre-Dame de la Crêche, and the new church, in memory of this and in gratitude for the queen's maternity, was dedicated *Jesu nascenti Virginique matri*. On the high altar was a

[1] Mâle, *A.R.C.T.* p. 16; Charvet in *Revue du Lyonnais*, XIX (1895), 158.
[2] It was finished in 1748 by Antoine Dégerardo.

marble group of the Virgin, St Joseph and the child Jesus, by Michel Anguier[1] (Plate 10). The dedication was remembered not only in the pictorial decoration of the church but also in the sculptured decoration with which it was enriched.[2] Here, as in its architecture, Italian influence is manifest; many of the figures and much of the scheme came directly from the *Iconologia* of Cesare Ripa.[3] The barrel roof of the nave (Plate 11) is adorned with an elaborate network of guilloche mouldings, framing circular medallions of the kings and queen to whom the chapels were dedicated, and oblong panels of angels holding scrolls. The arcades of the nave and choir have statues lying on them in the manner of those in St Peter's at Rome. The subjects, straight out of Ripa,[4] are the Virtues of the Virgin: Innocence washes her hands; Simplicity carries a dove; Charity holds a heart and has children at her knees; Force bears a club and wears a lion's skin; Temperance holds a bit; Patience joins her hands in silent prayer.

The arcades of St Anne's chapel and of the nuns' choir are adorned with 'emblems' from the chisel of Michel Anguier. They were designed especially for their position, possibly by a nun of the abbey; at all events a manuscript that re-cords them came from the possession of such a nun.[5] In the first arcade of St Anne's chapel they relate to the Mass. They include a burning heart on an altar, symbol of pious attendance at Mass; full and empty vases, signifying the soul that should be full of the love of God and empty of the love of the world; an altar with bread and wine, symbol of the Ancient Law; a censer, symbol of Christ and his burning love; and the Chalice, Host, book and candlesticks of the Christian altar.

The second arcade, in honour of St Joachim and St Anne, has a cube, symbol of a well balanced man; a bridal veil over two clasped hands, symbolizing fidelity; two horns of abundance; a mulberry tree, symbol of patience, for it only opens its buds when the frosts are over; a yoke with the word *suave*, emblem of the Christian faith; a hyssop, symbol of grace; a pine, symbol of austerity; and a willow that, growing beside flowing water, is an emblem of the believer enjoying divine blessings.

The third arcade has cornucopias as emblems of virtue; a fig tree, of sweetness and reticence; a pomegranate and myrtle, of love; and doves, of gentleness. A peach tree symbolizes truth, for its fruit is like a heart and its leaf like a tongue, and one rests upon the other; an almond, grace abounding; a cypress, death; while a

[1] The group is now in Saint-Roch, Paris. It was copied for the Abbaye aux Dames at Caen (now in La Gloriette) and for the Abbaye du Bec (now in Sainte-Croix de Bernay). Other replicas are at Demonville, Calvados, and at the Carmelites at Pont-à-Mousson (Réau, II, 2, p. 231). The plate illustrates the maquette belonging to Monsieur Jacques Dupont. Guillet de Saint Georges, I, 442, ascribes it to Michel Anguier; Piganiol de la Force, VI, 185, to François Anguier.

[2] The sculpture was begun in 1662 and seems to have been finished in 1667.

[3] The first edition of 1593 was not illustrated, but that of 1603 had engravings. The French translation by Baudouin published in 1644 was still more fully illustrated.

[4] See Mâle, *A.R.C.T.* p. 422.

[5] *Bib. Nat. nouv. acq. franc.* 10171; see Vauthier, p. 146.

poplar, black one side and white the other, like day and night, stands as a symbol of time.

On the fourth arcade an open book with flames and branches of oak stands for the Law of God, flaming with zeal and strong as oak. A budding vine is the symbol of struggle before fruition. A crown with two branches of olive stands for interior joy; two crowns of myrtle, for happy marriage; a pelican in its piety, for the tenderness of Christ; a bunch of keys, for prayer that opens the doors of heaven; a hammer and anvil, bound by a chain, for patience; a diamond ring holding two palms, for heavenly reward.

In the nuns' choir a cock represents vigilance; an olive tree, peace; doves and lilies, the blest in paradise; a stork, piety; a lamb, innocence. The nun who planned all this was steeped in emblematic lore.

The six domed chapels of the nave were dedicated to three sainted kings— Canute of Denmark, Eric of Sweden, and Louis of France, and three sainted queens of France, Clotilde, Bathilde and Radegonde; and it was intended that these should be represented in them.[1]

The cupola of the Val-de-Grâce (Plate 12) was commissioned from Mignard in 1663;[2] the iconography was worked out with the aid of his learned friend M. du Fresnoy. It shows Anne of Austria, led by St Louis and St Anne, holding up a model of her monastery in dedication. Round her are concentric circles of prophets and saints; first, Moses, David and the prophets; then the evangelists, the apostles and the martyrs; then the Fathers of the Church and the founders of religious Orders. Above them the Trinity are seated in glory, with the Virgin kneeling before them. A seven-branched candlestick, the Paschal Lamb, and the inscription 'Sic exultant in gloria Dei' linked the composition with the Apocalyptic Vision and with a tradition of Benedictine iconography at least as old as Moissac. The angels bearing the cross are in their turn inherited from the tympanum of Saint-Denis.

The chapel of the Sacrament has its half-cupola filled by a painting by Jean-Baptiste de Champaigne of about 1663, showing a half-length figure of Christ holding the Wafer in his right hand, surrounded by adoring angels.

Anne of Austria, as foundress, had her own apartments in the nunnery. For them she ordered pictures from Philippe de Champaigne;[3] a set of all the empresses and queens who had been held to be saints; a series of the life of St Benedict;[4] a picture of the Magdalen breaking the box of perfume over the feet of Christ; her communion;[5] and several others.[6]

[1] Piganiol de la Force, VI, 118.

[2] Lemonnier, *Louis XIV*, p. 314. Before the city became French the cupola of the transept of the Benedictine church of Sainte-Glossinde of Metz was painted by J. Girardet of Lunéville with the apocalyptic vision. [3] Guillet de Saint Georges, I, 242.

[4] Copies are at Versailles, and one picture is still at the Val-de-Grâce in a small chapel to the left of the sanctuary. See Guillet de Saint Georges, I, 242, and Descamps, II, 68.

[5] See Courajod, *Lenoir*, I, 46; Lossky, *Catalogue*, p. 104.

[6] E.g. Elijah's Dream, now in the Musée du Mans (Réau, II, 1, p. 354).

The discovery of the catacombs in 1578 gave a new impetus to the cult of saints already well established,[1] especially when an abbey held their relics. Sometimes a single statue sufficed, like the St Denis that Anne of Austria ordered from Jacques Sarrazin for Montmartre.[2] At Ferrières[3] the abbey had pictures both of St Aldric as an abbot and of the miracle of his head. The Benedictine priory of Saint-Julien[4] has six windows filled with the story of the life of the saint, and a statue of him over the fountain in the courtyard. At Nouaillé, St Julien is still represented by a terra-cotta figure; at Poitiers, Ste Radegonde was similarly figured in Sainte-Croix,[5] which also had a group of the Apparition of Christ to her. The abbey of Ferrières about 1620 acquired a retable with St Savinien and St Potentinien, the Evangelists of the Senonais, on either side of the Virgin, now in the church of Notre-Dame-de-Bethléem, and the priory of Conflans an altar picture of Sainte Honorine, whose tomb it enshrined, by Le Sueur.[6] At Saint Michel-en-l'Herm the patron saint appears in a medallion on the altar (Plate 13) by Michel Colombe. Jean Restout painted a picture of the profession of St Austreberthe for her house at Montreuil.[7] At Saint-Germain-des-Prés pictures of St Germain were accompanied by nine others of his life, by Cazes,[8] and by a picture of his martyrdom and of the translation of his body, by Hallé. St Martin was honoured at Marmoutier by two pictures by Le Sueur: one of St Martin's vision of the world as a globe of fire while celebrating mass (Plate 14) and one of the Virgin accompanied by St Agnes, St Thecla, St Peter and St Paul appearing to him (Plate 15)[9]. The first theme was repeated by Philippe de Champaigne[10] and Restout[11] for other monasteries. Elsewhere the dedication of a church inspired a picture; for example, the church at Saint-Amand, dedicated to St Stephen, was given a picture of the saint in prayer (Plate 16), attributed to Simon Vouet,[12] by Pierre Honoré, abbot from 1673 to 1693. Another, ascribed to Poussin and dated 1620, was given to his abbey at Caen. Often, too, the chapel of a saint was adorned with his picture, as was that of Saint Symphorien in Saint-Germain-des-Prés,[13] and innumerable others.[14] More rarely the saint was repre-

[1] Nouard's Martyrology had appeared in 1568.

[2] Now in Saint-Jean-Saint-François, Paris. [3] Réau, III, 3, p. 1117.

[4] Saint-Marceau, Sarthe. He is also represented by an eighteenth-century statue in the Cluniac priory of Pommiers-en-Forez.

[5] In marble, by Nicolas Legendre, who represented the saint with the *traits* of the queen. It is now in the crypt of Ste Radegonde. It was given in 1655.

[6] Guillet de Saint Georges, I, 166. It has disappeared.

[7] Now in the church of Saint-Saulve at Montreuil-sur-Mer.

[8] Courajod, *Lenoir*, I, 37. The series also included scenes from the life of St Vincent.

[9] Both are now in the Louvre. They were accompanied by pictures of St Louis and St Sebastian, now Tours Museum 122 and 123.

[10] Engraved by Claude Mellan, Picart and Hallé (*Bib. Nat. Cat. Estampes*, Rd 4 and Da 41).

[11] See Mâle, *A.R.C.T.* p. 503. One by Galliotti, dating from 1689, survives at Fleury.

[12] Now Valenciennes Museum no. 361. [13] Piganiol de la Force, VIII, 68; by Hallé père.

[14] E.g. St Joachim at the Religieuses-du-Calvaire (Guillet de Saint Georges, I, 276) and St Symphorien at Saint-Germain-des-Prés (Piganiol de la Force, VIII, 68). Many other monastic pictures of saints probably

sented by such a statue as the charming St Cecilia in Saint-Ouen de Rouen (Plate 17).

Naturally, many monastic churches contain pictures behind which the reason cannot now be divined. Why, for instance, does the church of the Cluniac priory of Pommiers-en-Forez contain a picture of St Irenaeus by Lefaivre dated 1663? Two other pictures of the saint with the wounded Sebastian, by Eustache Le Sueur, and Georges de la Tour survive, both apparently from the abbey of Lyre[1] (Plates 18, 19).

A natural consequence of this new stress on hagiology was the appearance of St Benedict and St Scholastica in the churches of his Orders, where till now they had hardly figured. The records suggest that their appearance dates only from the end of the sixteenth century. Representations of St Benedict alone are naturally characteristic of men's houses: a plaster statue of St Benedict is at Massay; a wooden one of the first half of the seventeenth century at Ambierle, and another at Pommiers-en-Forez. One of the abbot's rooms at Saint-Jean-d'Angely, rebuilt about 1630, has a relief of St Benedict over the chimney-piece; and he appears in glory on the ceiling of the cloister of Sainte-Melaine de Rennes about 1672. Saint-Germain-des-Prés had three pictures of St Benedict. Paired representations of St Benedict and St Scholastica are no less to be expected in houses of Benedictine nuns. Marble statues of the saints of the end of the sixteenth century survive in Notre-Dame-de-la-Couture at Le Mans. A contemporary statue of St Scholastica (Plate 20) survived at Jouarre until the first world war.[2] In the Benedictine nunnery of the Filles de Notre Dame at Soissons, stone statues of both saints by Gilles Guérin were set up about 1645.[3] Statues of the saints were soon in enough demand to justify their fabrication in terra-cotta; examples survive at Sainte-Sabine, Almanèches[4] and Loué[5] near Le Mans. One of St Benedict in stucco was made by Martin Desjardins about 1660 for the Benedictine nuns of the Saint-Sacrement at Paris.[6] Such statues began to figure in architecture; statues of St Benedict and St Scholastica were made about 1656 by Nicolas Legendre for the door of the Benedictine nuns at Issy.[7] Elsewhere the two saints were portrayed in pictures; the nuns of Notre Dame de Soissons, for instance, ordered pictures of St Benedict and St Scholastica from Nicolas de Plate-Montagne in 1686. Pictures of both saints survive at Sainte-Croix de Bordeaux. In pictures and sculpture for Maurist houses, St Benedict was sometimes accompanied by St Maur, who

come from the altars of side chapels, e.g. St Sebastian and St Louis by Le Sueur at Marmoutier (see above, n. 9) and an anonymous St Bartholomew, no. 236; St Philip at Saint-Germain-des-Prés.

[1] That by Georges de la Tour is now in the church of Broglie; that by Le Sueur in the Musée des Beaux Arts at Tours.

[2] The nuns went to Holland and the abbey was used as a hospital. During this interregnum a local antiquary sold it to (it is said) a Scots officer. Is the statue now in Scotland? Any information would be welcome.

[3] Guillet de Saint Georges, I, 261.

[4] In the chancel, dated 1674.

[5] Perhaps from the priory of Mareil-en-Champagne.

[6] Guillet de Saint Georges, I, 388.

[7] *Ibid.* 410.

figures beside him on the façade of Notre Dame de Rennes, erected in 1672, and appears, healing a child, on a pediment of the main building at Saint-Denis.[1] Van Dyck painted a picture of St Benedict receiving him and St Placidus at Subiaco for Anchin,[2] and Jean Restout painted the theme on the cupola of his chapel there.[3] Pigalle carved his apotheosis for the altar in his chapel in Saint-Germain-des-Prés.[4] Occasionally St Benedict is paired with a local abbot; at Saint-Chaffre he and St Théofrède appear side by side in medallions on the retable of the chapel of the latter saint.

A whole iconography of St Benedict was developed to be portrayed in pictures and reliefs. He appeared in meditation in a picture in a chapel of the little English Benedictine church of St Edmund in the Faubourg Saint-Jacques, and again on a retable of sculptured wood at Marmande (Plate 21). He was portrayed giving the Rule and performing miracles in three pictures in the sanctuary at Fleury;[5] raising a child from the dead at Ambierle; and dying at Nouaillé. In the eighteenth century his apotheosis was painted by Franceschini in the apse at Layrac, and Restout portrayed his ecstasy for Bourgeuil (Plate 22).

At the beginning of the eighteenth century the medieval refectory of Saint-Martin-des-Champs was adorned with a set of pictures of the life of St Benedict by Louis Silvestre the younger; one of St Benedict raising a child from the dead, by Silvestre, is now in the Louvre[6] (Plate 23); nine others are at Brussels and one at Béziers. In the Louvre picture the saint is rather theatrical, but the parents and child are realistic and the watching monks dignified and lifelike. They would have made a visible link between the world of miracles and the silent monks in the refectory. Those by Galloche[7] were set over the doors of the refectory; they represented St Benedict's miracle of the axe retrieved from the stream, and St Scholastica's of getting rain from heaven to prevent St Benedict from leaving her.[8] In 1707 the pulpit of the remote abbey of Locronan was adorned with medallions of St Benedict's life (Plate 24).

The dramatization of the saint's life was paralleled by that of his sister. In 1676 Nicolas de Plate-Montagne painted a picture of the death of St Scholastica for the

[1] Its pair was never sculptured; it may have been destined for St Benedict.

[2] Now in the Douai Museum.

[3] Now the chapel of Saint Margaret (Réau, III, 2, p. 934).

[4] It represented him rising to heaven, helped by angels, to receive a crown from St Benedict. It was destroyed at the Revolution (Réau, III, 2, p. 933).

[5] L. A. Marchand, *Souvenirs historiques sur l'ancienne Abbaye de Saint-Benoît-sur-Loire*, Orleans, 1838, p. 156. In the transept of the church at Vermenton there are two pictures by Etienne Jeauret of the saint in the cave at Subiaco and giving the Rule; they come from Reigny, *Cong. Arch. Auxerre* (1958), p. 281.

[6] No. 847A.

[7] See Guillet de Saint Georges, II, 291.

[8] A picture attributed to Jean Labbé in the Rheims Museum of St Benedict receiving oblates probably comes from one of the Benedictine houses in the city.

Dames Bénédictines du Saint Sacrement at Paris[1] and in 1730 Jean Restout painted a companion to his St Benedict in Ecstasy of St Scholastica dying in the arms of a nun, for the Benedictine monks of Bourgueil[2] (Plate 25). In a more historical spirit the Benedictine nuns of Notre-Dame-du-Pré at Le Mans in the sixteenth century set up a relief of the translation of the relics of St Scholastica from their church to the neighbouring church of St Benedict.

Such noble themes, however, were rarer than conventional pictures which were given a local significance by the inclusion of the figures of St Benedict and St Scholastica: they are particularly characteristic of Benedictine nunneries. For the Val-de-Grâce, for example, Stella[3] painted a Virgin between St Benedict and St Scholastica. For Saint Bénigne de Dijon a picture was painted[4] of a mystical marriage of St Catherine, with St Benedict to balance her. More devotionally, the Benedictine nuns of the Très Saint Sacrement at Paris[5] had a ceiling painted with St Benedict and St Scholastica together with angels upholding a tabernacle. The Benedictine Religieuses du Calvaire of Paris[6] had a picture over the high altar by Claude Vignon of the Holy Spirit in a sombre glory, with an eclipsed sun and angels weeping; below this St Benedict, St Scholastica and St Helena were represented gazing at a cross held by an angel. On a lower level were Jeremiah, David and Zechariah, who had predicted the death of Christ. The architectural frame was enriched by grisaille paintings of the twelve sibyls.

On the whole the French Benedictines, unlike some other Orders, did not create an artistic hierarchy of Benedictine saints. A repertory of engravings intended to inspire such representations was published in 1625[7] but does not seem to have had much influence in France. Exceptionally, a hierarchy of Benedictine saints appeared round the choir of Saint-Wandrille, from the brush of Sacquespée.[8]

Naturally, the sainted founders of monasteries were occasionally represented, both in reliquaries, like that of St Robert at La Chaise-Dieu (Plate 26), and in pictures. For example, the altar of St Robert at La Chaise-Dieu is surrounded by wall-paintings, contemporary with his reliquary, that represent his vision of the Blessed Virgin. St Eutrope, the patron saint of the Cluniac abbey at Saintes, is represented in a chapel of the Cluniac priory of Beaulieu, where a seventeenth-century picture shows him kneeling beside a Crucifixion. The Célestins of the

[1] Guillet de Saint Georges, I, 350.

[2] See Lossky, in 'Identifications récentes parmi les peintures françaises du Musée de Tours', *Bulletin de la Société de l'histoire de l'art français* (Paris, 1957) (BM W.P. 358/7), p. 107; now Tours Museum.

[3] Courajod, *Lenoir*, I, 127 (no. 894).

[4] Pointel and Montaiglon, III, 14; perhaps by Nicolas Quantin.

[5] Piganiol de la Force, VII, 295; it was by Nicolas Montaigne and Lespingola.

[6] Guillet de Saint Georges, I, 276.

[7] Imagines sanctorum Ord. S. Benedicti tabellis sereis expressae cum eulogiis ex eorundem ortis auctore R. P. F. Carolo Stengelio eius Ord. mon. S. Udalrici et Afrae Aug. Vind. Professo MDCXXV.

[8] Pointel, I, 245.

Marcoussis convent had a picture[1] (Plate 27) which shows the coronation as pope of their eccentric founder, with a pendant[2] of him giving them his modification of the Benedictine Rule. On their portal at Avignon their founder kneels with the tiara at his feet.

Most of the non-royal founders of the later period were too contemporary to be included in any conventual iconography, but Madame d'Orieux, who reformed the Benedictine nuns of Le Val-d'Osne to adore the Sacrament perpetually on the site of the Protestant Temple of Charenton, was represented soon after 1701 holding the church, with Louis XIV and Cardinal de Noailles beside her, in a great picture in the sanctuary.[3]

It was not a difficult transition from the sainted founders of monasteries to their historic benefactors. Abbot Antoine Bohier of Fécamp, who visited Italy in 1507, invited artists from Italy to decorate his church. Girolamo Viscardi of Genoa was commissioned, among other things, to adorn the high altar with reliefs of the Dukes of Normandy who had been the benefactors of his abbey[4] (Plate 28). At Saint-Martin-des-Champs the great door was in 1575 decorated with statues of the founders, Henri I and Philippe I.[5] At Brantôme a relief was carved in the seventeenth century with Charlemagne entrusting the relics of St Sicaire to the abbot. Historical allusions were particularly appreciated in Normandy. At Saint-Riquier two of the new stalls given by Charles d'Aligre about 1670 have carvings by Girardon of Charlemagne and Angilbert restoring the abbey, perhaps in delicate allusion to Aligre's own restorations. Yet, rather surprisingly, the magnificent lectern is borne by three *putti* without religious or historical significance. At Saint-Georges-de-Boscherville the confessionals are surmounted by medallions (Plate 29) of the founder, Raoul de Tancarville, William the Conqueror's chamberlain, and of St Benedict: the latter looks much like a portrait of the contemporary abbot. At the Abbaye aux Hommes at Caen the monks in 1765 ordered from Lépicié a picture of their founder William the Conqueror invading England.[6] It was intended for the refectory which it still adorns.

Benedictine refectories had a minor iconography of their own, naturally based on the repasts of the New Testament. An immense picture of the marriage at Cana, said to have come from the refectory of the monastery, now hangs in the nave of Saint-Pierre-de-Chartres; the Supper at Emmaeus was painted for Marmoutiers by Le Sueur,[7] for Saint-Martin-des-Champs by Jean Jouvenet about

[1] Now in the Louvre; painted for Pierre Julian, prior between 1525 and 1542. Another Célestin picture is Claude Vignon's Christ and the Doctors, now in the Museum at Grenoble, painted in 1623 for their Paris house.

[2] In the Dutey Harispe collection; see *Bulletin de la Société Nationale des Antiquaires de France* (1937), p. 138.

[3] Hélyot, III, 827. Nothing is left of her foundation or her picture.

[4] Most unusually, statues of two of them also adorn the façade of 1750. See Evans, *Monastic architecture in France* (Cambridge, 1964), Pl. 221. [5] Piganiol de la Force, IV, 10.

[6] See Diderot, *Salons*, III (1963), 4. It is a vast picture, 26 feet by 12 feet.

[7] Now at Lyons.

1706,[1] and for the Daurade of Toulouse by J. B. Despax in 1714. The subject of angels bringing food to Christ after the forty days in the wilderness was painted by Poilly, a pupil of Jouvenet's, for the refectory at Saint-Martin-des-Champs. At Notre-Dame-de-la-Couture at Le Mans, Parrocel in 1718 painted a whole series of pictures for the refectory:[2] Christ with Martha and Mary as a symbol of the active and the contemplative life; Christ fed by angels after the fast in the desert, as a symbol of rest after austerity; Christ with the woman of Samaria, as a symbol of the blessedness of water; the holy family resting on the way to Egypt, as a symbol of a time of refreshment in the monastic life. More simply, the Benedictines of Saint Vincent in the same city had pictures[3] for their refectory of the miraculous draught of fishes and of the multiplication of the loaves, and those of Bernay a still-life of fish.[4] In 1767 Lépicié painted pictures of the Baptism of Christ and of Christ bidding the Apostles to let children come near to him for the refectory of the Abbaye aux Hommes at Caen, where they still are.[5] By 1760 or so classical abstractions had invaded even this field, and the refectory of Saint-Bénigne at Dijon was adorned with a great sculptured allegory of Temperance, classical not only in style but also in feeling[6] (Plate 30).

The approximations of chapter-houses and sacristies to salons in the eighteenth century brought in fashionable *boiseries* and inset pictures that were often secular in style, like those at La Charité.[7] Often, however, such decorations were given a monastic flavour by the use of religious emblems in medallions, trophies of ecclesiastical objects (Plate 31), and perhaps censers instead of urns as ornaments. Their use was multiplied by the distribution of engraved designs.

A special iconography does not seem to have been developed for abbots' lodgings. In the prior's house at Carennac,[8] the salon has a ceiling of about 1600 of which the rafters are painted with cartouches and emblems in secular style. In the prior's bedroom there is a slightly later wall-painting over the chimney-piece of the Host in a monstrance surrounded by a glory. It affords a striking contrast with the decorations ordered in 1630 by Léonor d'Étampes, bishop of Chartres, who ordered from Mosmer a painting for the salon in his abbot's lodging at the abbey of Bourgueil of 'l'histoire d'Apollon et de Daphné d'une manière fort galante'.[9]

The commendatory abbot Charles d'Aligre did much for Saint-Riquier. The abbey had been burned in 1475 and 1487, and in a final fire in the Wars of Religion in 1554 what had been replaced was lost. Consequently when at last a generous abbot was installed—even though he was a layman who held the abbacy *in commendam*—he could plan his benefactions on a great scale. In 1690 he held a kind of competition for the pictures of the retables of the altars which

[1] Now in the Munich Pinakothek.
[2] Now in the church.
[3] Still preserved in their buildings, now a Museum.
[4] Now in the Bernay Museum.
[5] Diderot, *Salons*, III (1963), 36, 41.
[6] Now in the Dijon Museum.
[7] Now part of a vintner's store.
[8] Now the Hôtel du Château.
[9] Pointel, II, 17.

shows the balance poised between Benedictine subjects and the lives of saints honoured in the locality;[1] it may serve as an epitome of the Benedictine iconography of the time. The altar of St Benedict received a picture by Antoine Paillet of the oblation of St Maur and St Placide to the saint; that of St Peter, one by Claude Guy Hallé of Christ giving him the keys of heaven; that of St John the Baptist, a Baptism of Christ by A. Coypel; that of St Michael, a picture of the saint by Louis Silvestre; and that of the Virgin, an Annunciation by Louis Boullogne. Local interests were represented by the altar of St Angilbert, which received a picture by Bon Boullogne of the saint receiving the Benedictine habit; and the altar of Saint Gervinus, which had a picture by Louis Silvestre of his discovery of the body of St Angilbert. The abbey possessed the finger of St Marcou, abbot of Nanteuil, who had appeared to King Robert and endowed him and his successors with the gift of healing; his altar was given a picture by Jean Jouvenet that showed Louis XIV curing the King's Evil with St Marcou standing beside him.

In certain nunneries, notably the Trinité de Caen, it was evidently the fashion for nuns to offer votive pictures on taking their vows,[2] and in these St Benedict and St Scholastica were apt to figure. The Caen Museum includes two seventeenth-century pictures of the kind.[3] One represents the Adoration of the Shepherds, with St Benedict and St Scholastica holding a scroll on which a richly dressed woman is painted with a desk before her. A nun is shown signing her vows; the arms of the abbey and of Guerville are represented. The second picture portrays St Ursula with her companions sheltering beneath her cloak. The border has figures of St Benedict and St Scholastica and of the Annunciation, Visitation, Nativity, and Childhood of Christ. The arms of the Abbess Laurence de Budos and of the family of Quengo are represented, and a scroll once held the vow of a Quengo nun.[4] Less piously, Benedictine houses, like English colleges, began to accumulate portraits of distinguished members. A great many have disappeared, but those of the grand prior Guillaume Morin and the abbé Loup Servat survive at Ferrières-en-Gatinais.[5]

Gradually the new classical iconography began to influence monastic decoration by the introduction of abstract personifications. Before the end of the seventeenth century the abbess of Saint-Pierre de Lyon adorned her chapter-house with statues of Wisdom, Reform, Sincerity, Penitence, Humility and Silence,[6] and her refectory with figures of the monastic virtues. At Saint-Riquier the

[1] All but the Annunciation survive, if mostly in poor condition.

[2] They find a certain parallel in the seventeenth-century picture of a 'prise d'habit' in the left aisle of Sainte-Melaine de Rennes. Another by Bourdon went from La-Merci-du-Marais to the Louvre in 1792.

[3] Nos. 230 and 231.

[4] A votive picture from Notre-Dame-des-Nonnains at Troyes (Troyes Museum no. 274) shows the Virgin with the arms of an abbess of this house and of an abbess of Notre-Dame-des-Prés.

[5] They are now in the church of Notre Dame-de-Bethléem. Portraits of abbesses, too, were not unusual; e.g. that of Madame de Vermandois, now Tours Museum no. 225.

[6] See above, p. 7.

central pediment of the monastic buildings of about 1760 is sculptured with a figure of Faith accompanied by two allegorical figures and innumerable *putti*. The church of the Feuillants at Paris had statues of Humility, Faith, Hope and Charity on its portal.[1] Then for some fifty years such personifications went out of fashion. Eventually the tide turned; the entrance gate of Saint-Vaast d'Arras, rebuilt in 1754, was adorned with statues of Religion and Learning.[2]

[1] By Simon Guillain; Guillet de Saint Georges, I, 185.
[2] Cf. the library buildings at Saint-Riquier, with elaborate trophies of globes and instruments of the arts.

2

THE CISTERCIANS

When St Bernard laid down the Rule for his reform of the Benedictines, he proscribed any curious carving, stained glass, or paintings in the churches of his Order. None the less, its wealth and the benefactions showered upon it had by the end of the middle ages filled them with things of ornament and beauty. By the time of the Council of Trent it is fair to say that Cistercian abbeys were no less richly decorated than those of the parent Order.[1] Even their refectories were not without ornament (Plate 32). The Virgin was a favourite subject in an Order of which every house was dedicated to Our Lady. Their Lady altars were almost invariably adorned with her statue or her picture (Plates 33 and 34). Between 1541 and 1547 Primaticcio designed a chapel for Chaalis with a great Annunciation on the end wall, with God the Father above, borne by angels. The vaults were adorned with figures of the four Evangelists, the four Doctors of the Church, the Apostles, and angels bearing instruments of the Passion: a medieval scheme that he doubtless transmuted into something new and strange. The Annunciation appeared in many other Cistercian churches—for instance Noirlac—and was portrayed in a relief on the high altar of the Feuillants at Paris. At La Bénisson-Dieu the walls of the Lady Chapel were adorned with a whole series of paintings of the life of the Virgin. The fine Louis XIII choir screen at Pontigny has representations of the Annunciation and the Flight into Egypt modelled by Père Cambray.[2] Saint-Antoine-des-Champs at Paris had a Visitation by Claude Vignon.[3] A copy of Raphael's Holy Family adorned the altar of the Feuillantines at Paris.[4] The abbey of La Clarté-Dieu had a fine sixteenth-century sculptured group of the Adoration of the Magi, as well as seventeenth-century statues of the Virgin, St Joachim and St Anne.[5] The Feuillants also had a picture of the Assumption by Jacques Bunel; since the artist was a Calvinist, the figure of the Virgin was painted by Delafosse.[6]

The Cistercian devotion to the Blessed Virgin caused the rosary—essentially a Dominican subject—to figure in their iconography. Its devotions are represented in a fine picture from Bonport[7] (Plate 35) and in a sculptured retable from La Clarté-Dieu[8] (Plate 36).

[1] When I visited Pontigny in May 1959 the pictures, apart from those of the choir screen, were being carted away. Admittedly they were in a very bad state, but I hope their subjects were recorded before they were destroyed. [2] Guillet de Saint Georges, I, 116.

[3] *Ibid.* p. 277. [4] The original was at Versailles (Piganiol de la Force, VI, 161).

[5] It also had eighteenth-century statues of the four Fathers of the Church. All are now in the church of Saint Paterne, Indre-et-Loire. [6] Piganiol de la Force, II, 448.

[7] Now in the church of Pont-de-l'Arche.

[8] Now in the church of Saint Paterne.

The life of Christ was less commonly represented, though naturally most houses had a Crucifixion; but a fine retable of the Ascension from Bonport survives in the church of Pont-de-l'Arche (Plate 37) and a magnificent Ecce Homo (Plate 38) was painted for Port-Royal by Philippe de Champaigne.[1] Parrocel painted scenes of the Childhood and Passion of Christ for Valloires and Blanchard a Descent from the Cross for the Feuillants of Paris.[2] The Last Supper was painted for Port-Royal about 1648, on the traditional scheme in a more *mouvementé* style, by Philippe de Champaigne[3] (Plate 39); it has been suggested that the strong differentiation of the apostles is because they are portraits of the Port-Royal *Cénacle*.[4] The woman of Samaria figured in a picture at Port-Royal;[5] the Magdalen, by J. B. de Champaigne, at Saint-Antoine-des-Champs;[6] St Peter and St Paul at Noirlac.[7]

In Cistercian houses, St Benedict was apt to be accompanied by St Bernard rather than St Scholastica, though Noirlac had statues of all three.[8] At La Clarté-Dieu, for instance, their statues stand on either side of the retable of the Ascension (Plate 40), as they do beside the retable of the high altar, dated 1678, at La Grâce-Dieu,[9] and on the high altar at Le Relec. On the façade at Morimond, St Bernard's statue was paired with that of St Stephen Harding.[10] St Bernard was naturally often represented alone. The Feuillants of Aix-en-Provence, founded in 1655, had a life-size stone statue of St Bernard by Raimbault[11] and the Cistercian house of Avignon one of gilt wood.[12] Pictures of him were set up at Lieu-Dieu-en-Ponthieu[13] and a good bust survives at Saint-Jean, Châtillon-sur-Seine. At Le Thoronet, his statue was grouped with those of St Laurence and the Virgin and Child.[14] More often, he was included in the picture of a biblical theme; at Noirlac, for instance, he and St Benedict were represented on either side of a Last Supper.[15]

It was not long before scenes of St Bernard's life were represented in Cistercian houses. Louis Boullogne painted two pictures of his life for the nuns of Saint-Antoine-des-Champs to balance two of the life of St Anthony,[16] and Aubin Vouet painted scenes of his life for the cloisters of the Feuillants of Paris.[17] Philippe de Champaigne painted him[18] receiving illumination from heaven; Le Sueur in meditation before a crucifix;[19] Le Tellier portrayed him[20] seeing a vision of the

[1] On Philippe de Champaigne's work for Port-Royal see Blunt, p. 174.

[2] Now in the Louvre.

[3] Now in the Louvre.

[4] Gazier, p. 44.

[5] Guillet de Saint Georges, I, 242.

[6] *Ibid.* p. 348.

[7] Crozet, p. 11.

[8] *Cong. Arch.* 1931.

[9] Near Leyme, now in its modern parish church.

[10] Réau, III, 1, p. 458.

[11] Now in the garden of the Museum.

[12] Now in the Musée Calvet. Noirlac had a statue of him in the choir (Crozet, p. 11).

[13] Now in the church of Incheville.

[14] Now in the parish church of Lorgnes.

[15] Crozet, p. 11; *Cong. Arch.* 1931.

[16] Guillet de Saint Georges, I, 201.

[17] Piganiol de la Force, II, 448.

[18] Engraved by Morin.

[19] Copy from Fontgombault in the Museum of Chateauroux.

[20] Museum of Rouen; Pointel, I, 199.

Virgin and Child[1] (Plate 41); and Louis Van Loo pictured him in 1710[2] pointing to heaven and dictating his Rule to a monk, for the Feuillants of Aix-en-Provence. Père Etienne Prinstet, Procurator General of the Order at Rome, ordered from Joseph Passari for Cîteaux[3] a picture of him and his companions being received at Cîteaux by St Stephen Harding; all the monks were portraits of contemporary members of the house. For Val-Dieu Jean Restout painted St Bernard offering the Host to William of Aquitaine[4] (Plate 42). At Aubazine St Stephen was carved in relief, giving the Cistercian habit to his novices.

Exceptionally, the Feuillants went in for the representation of recent history. Their Paris house ordered a relief from Jean Goujon of Henry III receiving Jean de la Barrière, the reformer of the Order,[5] and had pictures of the reform painted in the windows of the library.[6]

A few portraits of individual abbots survive (Plate 43). Exceptionally, too, in the individualist society of Port-Royal votive pictures were painted to commemorate answers to prayer. Philippe de Champaigne painted portraits of Mère Cathérine Agnès Arnauld (Plate 44) and of his daughter Sœur Cathérine de Sainte Suzanne, to commemorate his daughter's cure from paralysis after Mère Agnès had prayed for her.[7] Two other votive pictures at Port-Royal, also attributed to him, showed the healing of Claudia Baudron and Marguérite Perier, niece of Pascal, by the Holy Thorn.[8] It was no doubt in allusion to this relic that Philippe de Champaigne painted a bramble beneath the foot of the Good Shepherd that he executed for the abbey; it is said[9] to figure in several other pictures from the abbey.

The last great Cistercian *ensemble* created in France was that of Valloires, of which the church was rebuilt between 1750 and 1756. The abbey possessed a tame artist in Pfaffenhofen, an Austrian who was a friend of the commendatory abbot. He produced a remarkable scheme for the church that brings to Valloires something of the air of a monastery beside the Danube. Its centre is the two-sided high altar (Plate 45a) with a double retable upheld by angels. The altar itself is a pedestal for the magnificent iron-work column that rises from it to swing over like a crozier to hold the pyx with the Host. Two angels kneel to adore; others fly from the ceiling (Plate 45b) to support it from above. The splendid organ-case

[1] The same scene was represented about 1637 by Philippe Boyster on the great door of the Feuillants in the rue Saint-Honoré; Guillet de Saint Georges, I, 281. It was also painted for the Bernardins of Dijon by J. B. Corneille; the picture is now in the Hôpital Général of the city; Auzas in *Bull. de la Soc. de l'hist. de l'art français* (1961), p. 58. [2] Now in the Museum at Aix.

[3] Mariette, II, 117. It was engraved by Nicolas Dorigny.

[4] Now in the Museum of Alençon (Réau, III, 1, p. 216). Restout's picture of his death, certainly from a Cistercian house, is now in the Tours Museum.

[5] It was later set in the façade of 1676 (Lenotre, *Paris révolutionnaire*, 1909, p. 66).

[6] Piganiol de la Force, II, 448.

[7] They used to hang in the chapter-house and are now in the Louvre.

[8] Now in the church of Saint-Merry at Linas.

[9] Lossky, *Identifications récentes parmi les peintures . . .*, p. 105.

has a gallery sculptured with musician angels and children symbolizing the Fine and Manual Arts. The retable of the apse (Plate 46), surmounted by a Crucifixion by Lebrun, has for its main picture one portraying the Virgin and Child presiding over the consecration of the church by the commendatory abbot Monsignor de la Motte and by the prior Dom Comeau. They reappeared in the side chapels: the statue of St Martin was a portrait of the abbot and that of St Bernard of the prior[1] (Plate 47). The transept has wooden statues of Moses, with the Tables of the Law, pointing to a bronze snake; Aaron casting away the Ark of the Covenant and pointing to the tabernacle of the high altar; St Peter with the keys and the reversed cross; and St Paul with the snake in the brazier. In the angles are reliefs of the four Evangelists in stucco. The scheme is logical and interesting; the themes that are at all unusual are soundly based on holy writ. The eighteenth-century liking for abstractions[2] and something of its intellectual attitude appear in the two groups in the choir. One represents Religion calling on Man to repent, and the other Man handing over to Religion the torch of his intelligence.

[1] They are now in Saint-Vulfran d'Abbeville.

[2] Similarly Simon Guillain carved four figures of Humility, Faith, Hope and Charity for the portal of the Feuillants in the rue Saint-Honoré (Guillet de Saint Georges, I, 185).

3

THE AUGUSTINIANS

The easier rule, ascribed by tradition to St Augustine, by which the clergy of a chapter lived as a community, had been since the middle of the eleventh century extended to other religious who wished to work in common, whether in nursing, teaching, or contemplation. The Augustinian Rule, never so strictly codified as that of St Benedict, was reformed in the middle ages in the Orders of Grand-mont, Fontevrault and Prémontré. In the sixteenth and seventeenth centuries many Augustinian houses in France were united in Congregations: the Grands Augustins, the Petits Pères, the Génofévains (so called from their centre in the ancient abbey of Sainte-Geneviève at Paris) and others.

The Augustinians produced an art critic early in the eighteenth century in the person of Chanoine de Cordemoy, of Saint-Jean-des-Vignes at Soissons. He published a conventional book on architecture in 1714,[1] of which the most inter-esting part is perhaps his remarks on the 'bienséances'[2] in which he permits himself to criticize current monastic painting.[3] He further criticizes the representation of the Virgin in the habit of an Order, and cites a picture of her in the scapular of the Mathurins in their church in Paris. He does not, however, give any account of the iconography of the Augustinians.

The Augustinian churches of the middle ages had been treasure-houses of miscellaneous works of art, as often given by individual members of the Order as by secular friends. Something of the same tradition survived into the centuries of the Renaissance. Sainte-Geneviève, for example, was c. 1600 given by Juste de Serres, bishop of Le Puy, a statue of Our Lady of Sorrows by Germain Pilon[4] (Plate 48). In 1658 Antoine de la Mare de Chênevarin gave the Grands-Augustins of Rouen a picture of the Holy Family resting on the way to Egypt by Le Tellier,[5] with the Virgin sitting on a pile of ruins and Joseph leaning on an antique altar, with a pyramid in the background. The church also owned pictures of the martyrdom of St Adrian and the Miracles of St Mathurin by Sacquespée.[6] The Génofévain church of Saint Acheul near Amiens has a group of the As-sumption by Cressent, and statues of the Virgin with the Seven Swords and of St Margaret. The Petits-Augustins of Paris had wooden statues of St Francis of Assisi and St Anne, and of Antonio Botta,[7] that had no particular reference to

[1] *Nouveau Traité de toute l'architecture, ou l'art de bien bastir* (Paris, 1714).
[2] *Ibid.* p. 122. [3] See below, p. 37.
[4] Now in the Louvre.
[5] Pointel, I, 199; now in the Rouen Museum.
[6] *Ibid.* 442; they may be those now in the church of Saint-Nicaise.
[7] Piganiol de la Force, III, 86.

the chapel where they stood. A considerable number of disparate pictures and statues may still be found in the remoter Augustinian churches. The church of Saint Laon at Thouars, for example, contains unusual plaster groups of the Resurrection and Ascension and a picture, of the school of Vouet, of Christ and the Woman of Samaria. The regular Augustinian nuns of Val-Paradis, near Espagnac, had a good altar-piece of the Ascension. Augustinian patrons often followed the medieval tradition of iconography; at Sainte-Geneviève, for example, Laurent Magnier about 1680 made a seated Virgin and Child[1] for the dorter staircase, with the four prophets—Daniel, Ezekiel, Jeremiah and Zechariah—who had predicted the coming of Christ, all life-size.[2]

The imagery of the Renaissance emblem-engravers figures less often in Augustinian houses than one might expect. At Saint-Pierre-en-Vallée at Auxerre the gateway has couchant statues in the tympanum labelled Ceres and Noah, perhaps in allusion to the abbey's riches in corn and wine.

Royal gifts continued to introduce themes more appropriate to the donor than to the monastery. About 1670 Le Hongre made a silver-gilt reliquary for the Petits Pères of Paris at the order of the queen in fulfilment of a vow made by her and Maria Theresa of Austria before the birth of the Dauphin. It represented the kneeling St Theresa holding the child: the reliquary contained one of her bones.[3] Another gilded figure[4] represented a guardian angel offering a child to the Virgin; it was given by the Duc d'Orléans in memory of a son who died before he could be christened.

There was, none the less, an Augustinian iconography. We may guess at a special devotion to the Virgin of the Seven Sorrows; a chapel was dedicated to her in Notre-Dame-des-Victoires, and she was represented in such typical provincial Augustinian houses as the Discalced Augustinians of Aix-en-Provence[5] and the Génofévains of Saint-Acheul. Other predilections are better capable of proof.

Just as St Benedict was the most frequent subject in Benedictine sculpture and painting, so was St Augustine in the houses that followed the Augustinian Rule. He was usually represented as a member of the Order, wearing over his habit the leather belt that was its distinguishing mark.[6] The saint was occasionally represented by a statue, as in that made by Laurent Magnier for the courtyard of Sainte-Geneviève in 1680,[7] and that, balanced by a St Stephen, set on the façade of Saint-Etienne de Rennes some twenty years later. Pigalle, too, carved a statue of him for his chapel in Notre-Dame-des-Victoires;[8] and he appeared

[1] The child was represented standing, a peculiarity that reappeared on the foundation stone of Notre-Dame-des-Victoires. Piganiol de la Force, III, 85. [2] Guillet de Saint Georges, I, 420.

[3] *Ibid.* I, 371. It had a pendant in a figure of St Cyriacus given by a canon of the house.

[4] Piganiol de la Force, III, 108.

[5] Pointel, I, 47; St Peter and St Anthony stood on either side. The picture is now in the Cathedral.

[6] Mâle, *A.R.C.T.* p. 455. [7] Guillet de Saint Georges, I, 420.

[8] Piganiol de la Force, II, 86.

on the foundation stone of the church, holding a heart pierced by an arrow.[1]

The lesser cloister of the Augustins of Toulouse, built in 1626, was in 1641 beautified by stucco statues by Frère Ambroise Fredeau, a monk of the house,[2] of the Virgin and the principal Augustinian saints—St Augustine, St Monica, St Clare of Montefalco, St John Bonus, St Nicolas of Tolentino, St Thomas of Villanova, St William of Aquitaine, St Rita of Cascia, St John of Sahagun and St Catherine.

St Augustine was far more often portrayed in pictures. The Augustinians of Bourges had pictures of St Augustine and St Monica painted by J. Boucher about 1620;[3] the Grands-Augustins of Paris, one by Louis Licherie of an angel bringing a mitre and crozier to the sleeping child Augustine while a second angel showed his mother Monica a copy of the Rule.[4] At Notre-Dame-des-Victoires there was a whole series of pictures of his life, painted by Van Loo, Galloche and others, between 1750 and 1753, hanging in the refectory; his conversion, his baptism, the death of St Monica, his ordination, a picture of him preaching, his consecration as a bishop, his disputation with Donatist bishops, one of his miracles,[5] his death, and the translation of his body to Pavia. The Library at Sainte-Geneviève de Paris had its ceiling painted by Jean Restout in 1750 with the apotheosis of the saint.[6] Sacquespée painted a picture of him healing a man possessed of a devil, and another of an angel touching the saint's brow, for Saint-Maclou de Rouen.[7] His baptism by St Ambrose and his consecration as bishop of Hippo are represented in two pictures by Louis de Boullogne, now in the Dijon Museum[8] (Plates 49 and 50), which must have been painted for an Augustinian house. His baptism figured above his altar at Saint-Loup de Troyes.[9] A picture, now in the Museum of Moulins, portrays him washing the feet of a pilgrim who is Christ (Plate 51). Another, by Nicolas Pierre Loir, now in the Musée David at Angers, shows him in ecstasy holding a flaming heart. The sacristy of Notre-Dame-des-Victoires has a picture of him asking Christ for the gift of charity, and another of him worshipping Christ, as well as a Virgin and Child with St Augustine and St Monica at their feet. The Génofévain house of Saint-Jean-de-Cole in the Dordogne still has late seventeenth-century pictures of St Geneviève and St Augustine,[10] and their other house at Évaux in the Creuse a relief of the same date showing the saint giving his Rule to his canons and St Geneviève.[11]

[1] Piganiol de la Force, III, 86.

[2] See Mariette, II, 272. He is said to have been a pupil of Simon Vouet's.

[3] Pointel, II, 109. [4] Guillet de Saint Georges, II, 64.

[5] Possibly the picture of the saint curing a madman by Parrocel which went to the Louvre in 1792. The picture of his baptism was exhibited at the Salon of 1755 (Réau, III, 1, p. 152).

[6] Réau, III, 1, p. 156. [7] Pointel, I, pp. 242–3.

[8] Nos. 237 and 238. [9] Réau, III, p. 153.

[10] The choir also has pictures of St Agatha, St Sebastian, the presentation of Samuel to Eli, the Baptism of St John, St John the Divine in ecstasy at Patmos, and St Anthony.

[11] The Génofévains took over Evaux from the Augustinians in 1634.

The Petits-Augustins of Paris were dedicated to St Nicolas of Tolentino. Seventeen pictures of his miracles adorned the nave,[1] and seven more were in the chapter-house. On the high altar[2] was a stucco group by Pierre Biardeau of a dying man upheld by an angel, while the saint prays for him, with St Clare of Montefalco[3] and St Monica in nun's habits. Frère Ambroise Fredeau painted St Nicholas for the sacristy of the Augustinians at Toulouse (Plate 52), and Claude Guy Hallé for an Augustinian house probably in Grenoble (Plate 53). The other saints of the order were more rarely represented, though Louis Licherie painted a picture of St Thomas of Villanova giving alms to the poor for the Grands-Augustins of Paris.[4]

St Anthony, St Paul the Hermit, and St John the Baptist were regarded as their patrons by the Augustinians,[5] and they had a devotion for St Peter as the type of papal authority. St Anthony was represented in a series of pictures at the Grands-Augustins,[6] and with St Peter kneeling before the Virgin of the Seven Sorrows in a picture painted by Daret in 1640 for the Discalced Augustinians of Aix-en-Provence.[7] The latter church also had pictures by the Darets of Christ giving St Peter the keys, Christ walking on the waters, and Peter weeping for his denial.[8] The saint was represented curing the sick as his shadow passed over them in a picture by Jouvenet in the Grands-Augustins of Paris.[9]

The Grands-Augustins of Paris seem to have devoted special care to the schemes of their imagery (Plate 54). The half-dome was filled with a relief of God the Father with angels, by Le Brun, and statues of St Augustine and St Monica stood on the high stylobate. The pulpit set up in 1588[10] had three reliefs of preaching by Germain Pilon: St Paul preaching, St John the Baptist preaching in the desert, and Christ teaching the woman of Samaria. It was borne by six angels carrying instruments of the Passion. The choir was hung[11] with seven pictures of the Eucharist and its Old Testament analogies.[12] The Augustinian canons of the abbey of Saint-Victor had a pair of pictures by Jean Restout of the Last Supper and of Melchisidech giving Abraham bread and wine.[13]

Exceptionally, Augustinian imagery had a local interest. In the middle of the seventeenth century Jeanne Péraud at Aix-en-Provence had a vision of the child Jesus bearing the instruments of the Passion. A little later a statue and a picture of the vision were set up there in the church of the Discalced Augustinians.[14]

[1] Stein, p. 76; Mâle, *A.R.C.T.* p. 463. Guillet de Saint Georges, II, 293, ascribes them to Louis Galloche and says he was badly paid for them. [2] Stein, p. 45.

[3] So Piganiol de la Force, VIII, 235; Stein says Ste Victoire.

[4] Guillet de Saint Georges, II, 64. [5] Mâle, *A.R.C.T.* p. 455.

[6] Courajod, *Lenoir*, I, 139. [7] Pointel, I, 47.

[8] *Ibid.* I, 5. [9] Piganiol de la Force, VII, 116.

[10] *Ibid.* VII, 124. He says it was spoilt by being gilt in 1684. [11] *Ibid.* VII, 116.

[12] As it was the chapel of the Order of the Saint-Esprit, it also held five pictures of its ceremonies.

[13] Piganiol de la Force, V, 260. He also painted for them a Resurrection of Lazarus and a David in Prayer.

[14] The statue is now in the Cathedral: it is dated 1677; the picture is in Sainte-Madeleine.

With the eighteenth century a liking for less hagiological subjects made itself felt among the Augustinians as in the rest of the French world. At Notre-Dame-des-Victoires the fine classical library had its ceiling painted in 1703 by a Neapolitan painter, Paolo Mattei,[1] with a typical composition of abstractions; Religion, aided by Truth with a sun on her breast and a whip in her hand, attacked Error. An angel stood by with a book inscribed: 'Quare detraxistis sermonibus Veritatis?'[2] The later woodwork of Notre-Dame-des-Victoires is carved, not with scenes of the life of St Augustine, but with medallions of abbatial insignia.

It was planned to surmount the dome of Sainte-Geneviève with a pedestal with a great statue of Religion; but the medieval tradition was to be maintained by the statues of the four Evangelists on the pedestal and the eight Fathers of the Church round the drum.[3] At the same time the pediment of the west front was filled by Coustou with sculptures representing the triumph of the Faith.[4] The peristyle had a series of reliefs, all destroyed at the Revolution: St Peter with the keys, by Houdon;[5] St Paul preaching on the Areopagus, by Boizot in 1776; St Geneviève giving bread to the poor, by Beauvais, restoring sight to the blind, by Julien, and receiving a medal from St Germain by Dupré.[6] The last subject was also represented in paintings by Louis de Boullogne[7] and Louis Lagrenée.[8] A picture by Michel Corneille, now in the Nantes Museum, of St Médard giving St Geneviève the palm of martyrdom,[9] may also have come from the Paris house. The picture which Francisque Millet exhibited at the Salon of 1765, a landscape with the figures of St Geneviève and St Germain, was also probably intended for a Génofévain monastery.[10]

The houses of the old Augustinian reforms—Grandmont, Fontevrault and Prémontré—suffered severely in the wars of religion, and have not left enough to establish a post-Reformation iconography for them.[11] At Fontevrault the chapter-house, rebuilt in the years following 1540, has reliefs of St Benedict, St Scholastica and St Nicolas. It was later completed by frescoes of the Passion of Christ by Thomas Pot and by portraits of abbesses (Plate 55). The washing-fountain was adorned with five leaden statues representing the Baptism of Christ. A seventeenth-century statue of St Étienne de Muret, the founder of Grandmont, by P. Biardeau, survives at the priory of Breuil-Bellay.[12]

Even after the Renaissance the Premonstratensians remembered their founder, St Norbert; scenes of his life are carved on the stalls of the Premonstratensian

[1] Piganiol de la Force, III, 122.

[2] Job vi. 25. The walls above the bookcases were hung with portraits of benefactors.

[3] Dargenville, *Vies de quelques peintres célèbres*, Paris, 1945, I, 484. The scheme was never carried out.

[4] Removed at the Revolution. [5] Réau, III, 1, p. 156.

[6] *Ibid.* III, 2, p. 566. [7] Now in the church of the Assumption, Paris.

[8] Now in Saint-Thomas-d'Aquin (Réau, III, 2, p. 566).

[9] Réau, III, 2, p. 666. [10] Diderot, *Salons*, III (1960), 26.

[11] At Verdun one of the cells has a relief of the Sacrifice of Isaac over the chimney-piece; cf. that at the Cistercian abbey of Boulbonne

[12] Réau, III, 1, p. 458.

house of Vicogne.[1] At Sarrance the church is adorned with statues in gilt wood of St Augustine and St Norbert, and with plaster reliefs of Saints Benedict, Fulgence, William Bruno, Blaise and Anthony. The Premonstratensian church in Paris, built about 1690, was adorned with sculptures by Le Hongre.[2] On the attic was a large medallion of the Sacrament carried by angels and adored by others. Above the great door was a relief of the unusual subject of the Conception of the Virgin, with God the Father, St Anne, St Joachim and a tiny figure of the Virgin in glory.

In the eighteenth century the Premonstratensian Père Eustache Restout, prior of the abbey of Mondaye, not only acted as architect to his abbey, but also painted pictures for it;[3] their subjects are drawn from the general scheme of Catholic iconography and show few particularities. The retable in the chapel of the Virgin is by Melchior Verly (Plate 56).

The seventeenth century witnessed the foundation of a number of new Orders of men and women whose way of life was based on the Augustinian Rule. The many nursing Orders are remembered for their work rather than their possession. A picture was painted for the Narbonne house of the Sisters of Charity in 1786 by Jacques Gamelin[4] (Plate 57) but characteristically it was a gift to them from M. de Lastour, Grand Archidiacre of Narbonne, in memory of a relation. It shows the sisters in prayer before their founder, Saint Vincent de Paul, to whom they present two orphans.

The small Order of Notre Dame de Charité du Refuge, founded in 1711 at Caen, had a house in Paris, three branch houses in Brittany and another at Besançon. They followed the Augustinian Rule and cared for penitent women; spiritually they were linked with the Visitandines. They owned a picture of the nuns adoring Sacred Hearts of Jesus and Mary by Jean Lamy (Plate 58) and an Assumption by Charles Lamy (Plate 59);[5] and in their fine and ornate chapel at Besançon they had an Assumption over the high altar (Plate 60) and a painted dome.

The teaching Order of the Ursulines has left more memorials in France, though their buildings are generally of an economical austerity. The façades of the churches at Espalion and Abbeville, both of the time of Louis XIII, are adorned with the device of the pierced heart. This does not seem to recur; possibly it was superseded by the Visitandine cult of the Sacred Heart of Jesus. The Ursulines shared in the Augustinian devotion to St Augustine and his mother, and added to them St Ursula, St Charles Borromeo, and a number of female saints.[6]

[1] Now in the church of Saint-Géry, Valenciennes. [2] Guillet de Saint Georges, I, 365.

[3] An exhibition of them was held at Mondaye in 1957.

[4] Now in the Narbonne Museum, no. 116.

[5] Both are now in the Musée des Beaux Arts at Tours; see Lossky, *Etudes et Documents sur l'Art Français du XII au XIX siècle. Archives de l'Art Français* (1955).

[6] See Hélyot, III, 773, 793. Sometimes their chapels were adorned with pictures by members of the community; for instance, the daughter of Quentin Varin painted the chapel at Amiens (Mâle, *A.R.C.T.* p. 15).

It was natural that an Order of women devoted to education should feel a special link with the mother of Christ. The tympanum of the door to the chapel of the Ursulines at Auxerre (Plate 61) represents a familiar medieval theme modified to their use: the Virgin stands with outspread arms and the nuns of the community shelter beneath her cloak. At Aix-en-Provence the façade of the chapel has a statue of the Virgin between statues of St Augustine and St Ursula. The Annunciation was painted by van Mol for the high altar of their house in the Faubourg Saint-Jacques;[1] it was also painted by Charles Delafosse in a wreath of flowers by Monnoyer for the chimney-piece of their parlour at Valenciennes.

The Dijon house owned a head of the Virgin by Jean Tassel,[2] as well as pictures of the Presentation of the Virgin (Plate 62) and of Christ in the Temple, by the same artist. A statue of Joseph holding the Child Jesus was carved for them by J. B. Bouchardon in 1718. Jean Tassel painted for them a Coronation of the Virgin by the Infant Christ, with a portrait of their foundress, St Angela Merici (Plate 63). A statue of her, standing near a prie-dieu and bending towards a crucifix, was carved by Pfaffenhofen for the Ursuline house at Abbeville in honour of her beatification in 1768.[3]

St Augustine figures on the façade of the chapel of the Versailles house of Ursulines, paired with St John Chrysostom, with modern parallels in Fénelon and Bossuet. Over the door a relief by Deschamps shows the queen and her daughters receiving the little girls from their mothers. A stone statue of St Ursula stood on their portal at Pontoise; a picture of her embarking with her companions, by Besnard, dated 1687, hung in their chapel at Angers; and their Caen house had a tapestry of her martyrdom designed by Le Feye.[4] Exceptionally, the Ursulines of Château-Gonthier—a house dedicated to the Trinity—had an altar-piece representing this. God the Father, a Judaic, black-haired figure, sits beside a gracile young standing Christ, who shows his wounds; the dove of the Holy Ghost hovers between them. It is a curious composition, that tries to translate the symbolic formula of the middle ages into the naturalism of the reign of Louis XIII.

Little survives from Saint-Cyr. A picture of St Julitta by Durameau is now in St-Nicolas-du-Chardonnet,[5] and pictures by Jollain of the Martyrdom of St Cyr and St Julitta, and of St François de Sales receiving Extreme Unction, painted for the house, were exhibited at the Salon of 1767.[6]

Exceptionally, Ursuline convents owned a few portraits of their more distinguished members; one of Cathérine de Montholon, their foundress, by Jean Tassel, survives from the Dijon house (Plate 64).

[1] Piganiol de la Force, VI, 134.

[2] Now in the Dijon Museum. On his work for the Ursulines see H. Ronot, 'Les dessins des peintres Tassel récemment découverts', in *Bull. de la Soc. de l'hist. de l'art français* (1955), p. 86.

[3] Réau, III, 1, p. 89.

[4] The cartoon is no. 164 in the Caen Museum.

[5] Réau, III, 2, p. 775.　　　　　　　　[6] Diderot, *Salons*, III (1963), pp. 40–1, 290.

The next teaching Order to be founded under the Augustinian Rule, the Dames de l'Assomption,[1] built a new and splendid chapel in 1670. Its iconography was dictated by its dedication. Charles Delafosse in 1676 painted the choir vault with the Coronation of the Virgin and the cupola with the Assumption.[2] Four great pictures of the Visitation, Purification, Annunciation, and Marriage of the Virgin hung under the dome. The high altar has a picture of the Nativity by Rouasse.[3] Louis Testelin painted pictures for them, before 1648, of the Visitation, the Adoration of the Magi, the Flight into Egypt, and Christ among the doctors;[4] Vien, an Annunciation in 1767; and Suvée, a Birth of the Virgin in 1779. There was a great crucifix by Noël Coypel; it was said that the Virgin at its foot looked younger than the Christ above. The altar of St Augustine was crowned by a figure by Gerard van Obstal of the child Christ holding a cross with a serpent turning round the foot, to symbolize the saint's destruction of the Manichaean heresy.[5] The nuns' devotion to female saints was represented by pictures of St Agnes and St Margaret.[6]

The French church in the seventeenth century realized as never before the spiritual importance of mystical devotion. Several of the contemplative Orders of women that were founded at that time followed the Augustinian Rule, since it left more time free for meditation.

The most important of these Orders was that of the Visitation, founded at Annecy in 1610 by St François de Sales and St Jeanne de Chantal. In 1616 it became an enclosed religious Order, following a mitigated version of the Augustinian Rule.

A letter from St François de Sales to St Jeanne de Chantal[7] describes the scene of the Nativity in the terms of a painting by Georges de la Tour.

Il n'est pourtant point dit que Notre Dame et Saint Joseph, qui étaient les plus proches de l'enfant, ouyssent la voix des anges ou vissent les lumières miraculeuses. Au contraire . . . ils oyaient l'enfant pleurer et virent, à quelque lumière empruntée de quelque vile lampe, les yeux de ce divin garçon tout couverts de larmes et transissant sous la rigueur du froid. Or, je vous demande en bonne foi, n'eussiez-vous pas choisi d'être en l'étable ténébreux et plein des cris du petit?

None the less, it can hardly be maintained that such naturalism is consistently found in Visitandine paintings.[8] Each Visitandine house—and by 1641 there were eighty-six in France—was autonomous, and this independence encouraged variety in their architecture and in their works of art. All the same, they had a certain homogeneity in the subjects of their imagery. The scene of the Visitation of the

[1] Sometimes called the 'Nouvelles Haudriettes' (see Hélyot, II, 447).

[2] Guillet de Saint Georges, II, 12; Blunt, p. 272.

[3] Piganiol de la Force, III, 17. [4] Guillet de Saint Georges, I, 219.

[5] *Ibid.* p. 177. It may also perhaps have alluded to the current Jansenist heresy.

[6] By Louis Testelin; Guillet de Saint Georges, I, 219. [7] *Œuvres*, XIII, 203.

[8] The 'Grande Visitation' at Annecy, not then French, has elaborate mid-seventeenth-century retables of the Virgin of the Rosary, St François de Sales, two bishops and other saints, in the conventional manner of the time.

Virgin and St Elizabeth was naturally extremely popular; Jean Dubois carved it for Dijon;[1] Mignard painted it for the high altar of the Orleans house in 1660;[2] Charles Delafosse for Tours;[3] Charles Lagon for Lyons;[4] Reynaud Levieux for Aix-en-Provence;[5] Claude Vignon for the high altar of the Paris house and Nicolas de Plate Montagne for a chapel;[6] François Puget for that at Marseilles[7] (Plate 65); Nicolas Mignard for Avignon[8] and Suvée for the Paris house.[9] An eighteenth-century picture of the Visitation, together with a pendant of the Nativity, still hangs in their chapel at Avallon.[10]

The life of the Virgin was naturally a favourite subject. Claude Vignon painted a whole series for the chapels of the Paris Visitandines;[11] on the right were the Birth of the Virgin, her presentation, her education by angels, her occupations, the Assumption, and the Adoration of the Magi; on the left, her Conception, the Nativity, the Presentation of Christ in the Temple, the Flight into Egypt, and the Virgin receiving the body of Christ from the Cross. The choir of the Visitandines of Moulins has its ceiling painted with a long series of scenes from the life of the Virgin, with medallions of Charity, Religion, Faith, Hope, Fidelity, Prayer and Modesty. Louis de Boullogne painted the Presentation of the Virgin, the Annunciation and the Assumption, for the Visitandines of Orleans;[12] the Aix-en-Provence nuns had a Presentation of 1630[13] and those of Moulins another by Pietro da Cortona;[14] those of Marseilles a Virgin crowned by the Child Jesus, by Pierre Parrocel[15] (Plate 66); and the Clermont Visitandines an Annunciation by Louis Testelin.[16] At Le Mans the Visitandines acquired a fine picture painted by Restout in 1754 of a mystical Adoration of the Sacred Heart that still hangs above their high altar. An Entombment group of figures by Philippe Buyster was set up about 1665 in a garden house of the Paris Visitandines; it was given by Mademoiselle d'Orléans, Duchesse de Montpensier, as a subject for meditation.[17]

The convent of the Visitandines of Chaillot had no less than a hundred and seventy-three pictures in their church and in their conventual buildings. A number were by Louise Hollandine,[18] daughter of the Elector Palatine. A pupil

[1] It is now in the church of Sainte-Anne.

[2] Guillet de Saint Georges, I, 202; Auzas, in *Bull. de la Soc. de l'hist. de l'art français* (1959), p. 23.

[3] It may be the picture now in the Tours Museum. [4] Mariette, III, 41.

[5] Pointel, I, 90. It was given by a niece of Cardinal Mazarin and is now in the church of the Madeleine. It was flanked by pictures of the Nativity and the Presentation which are now in the chapel of Saint-Jean-de-Malte.

[6] Guillet de Saint Georges, I, 352. It was flanked by pictures of Christ in the Garden and the Conversion of St Augustine. See also Auzas, p. 29. [7] Now Marseilles Museum no. 452.

[8] Auzas, p. 27. [9] Courajod, *Lenoir*, I, 38 (no. 26A).

[10] Now the church of Saint-Martin.

[11] Guillet de Saint Georges, I, 276. They also had an Assumption in the dome of the Lady Chapel, by François Perrier (*Ibid.* p. 134). [12] Guillet de Saint Georges, I, 202.

[13] Now in the church of Saint-Jean-de-Malte. [14] Over the altar.

[15] Now Marseilles Museum no. 371. [16] Guillet de Saint Georges, I, 220.

[17] *Ibid.* p. 285.

[18] See Vauthier who says that a dozen of her pictures are still in the possession of the Paris Visitandines.

of Gerard Honthorst, she entered Chaillot as a convert to Catholicism in 1658, and painted steadily until she was sent to the Cistercians at Maubuisson. The sequestration list of 1791 includes a Visitation and a Flight into Egypt.

A second painter at Chaillot was Anne Marie Renée Stressor, daughter of a German painter, who had been a professional miniaturist before she entered the Order. She painted innumerable pictures for them, mostly copies, of the lives of Christ and the Virgin, before her death in 1713.

A curious picture still in the nuns' choir at Moulins represents St Augustine with all sorts of emblematic subjects; it is the kind of thing that might well have been painted by a nun. The Visitandines, indeed, sometimes remembered St Augustine, to whom they owed the basis of their Rule. He and St Joseph stand on either side of the retable at Moulins. The Saint-Denis house had pictures by Louis Galloche of his baptism and of his meeting of a child on the seashore while he meditated on the doctrine of the Trinity,[1] and the Paris Visitandines one by Nicolas de Plate-Montagne, of his conversion.[2]

Naturally, the founder, St François de Sales, had an iconography of his own. He was painted by Jean Restout for the Visitandines of Le Mans;[3] by Le Brun for the Paris house[4] and by François Puget for Marseilles.[5] Louis Durameau painted him receiving extreme unction for Saint-Cyr in 1760,[6] and in the same year Natoire painted his Apotheosis for the Visitandines of Nîmes.[7] The Chaillot nuns had a picture by Restout of Madame de Chantal giving the Constitution of her Order to the nuns; another of the same subject by Noël Hallé survives in the church of St Louis-en-l'Isle at Paris.

Sœur Marguérite Marie Alacoque had her vision of three conjoined hearts of glorious light in her Visitandine convent at Paray-le-Monial in the spring of 1675. Her influence only grew after her death and the theme is unusual in monastic houses, though, exceptionally, it figures on an altar with a painted retable that cannot be much later than 1700 which survives in the Cluniac priory of Beaulieu. Otherwise the only monastic instance that I can cite before the Revolution is the picture of a retable that still survives in the chapel of the Visitandines of Le Mans, between statues of Mother Mary Alacoque, who has a heart above her brow, and St Catherine. One of the side walls of the apse is adorned with stucco figures of angels bearing the Sacred Heart. Exceptionally, a Visitandine portrait may be found; a fine one is preserved at Avignon.

[1] Guillet de Saint Georges, II, 303. [2] Guillet de Saint Georges, I, 352.
[3] Réau, III, I, p. 542. Now in the church of Ste-Marguérite, Paris.
[4] Piganiol de la Force, VI, 133; Jouin, p. 489. [5] Courajod, *Lenoir*, I, 107 (no. 763).
[6] Réau, III, I, p. 543. Now in St-Nicolas-du-Chardonnet. [7] *Ibid.* Now in Nîmes cathedral.

4

THE CARTHUSIANS

The Carthusians, the oldest Order devoted to the contemplative life, took on new energy in the mystical atmosphere of seventeenth-century France. They had a long tradition of devotional painting; at Champmol, in the fourteenth century, each cell had held a picture to serve as a focus of its occupant's meditations. The tradition was continued in the later centuries:[1] the Charterhouses were notably rich in pictures. A Carthusian monk published a book of emblems in Paris in 1655,[2] but they are true emblems almost in the manner of Quarles, with abundant literary explanations. They may well have inspired a few paintings over chimney-pieces in country Charterhouses, but could have been of no use for more important paintings.

St Bruno, the founder of the Carthusians, was beatified in 1514 and made a saint in 1623. His life forms the basis of their characteristic iconography. The Charterhouse of Paris had its lesser cloister adorned with a series of paintings of the life of St Bruno by Le Sueur between 1645 and 1648 (Plates 67 and 68). The cloister was glazed;[3] the walls opposite the arcades were arranged in a sham arcade, of which the niches held the pictures alternating with panels giving the story of the saint in Latin verse.[4] At the angles pictures by other hands portrayed the most celebrated monasteries of the Order: Rome (Plate 69), Paris and the Grande-Chartreuse.[5] Le Sueur's twenty-two pictures were acquired by the king in the years after 1776;[6] the convent, which was half ruined, gave them in the hope of a munificent return. They are now in the Louvre. They are among the noblest of Le Sueur's compositions; in them he seems to hark back to a medieval tradition of austere narration.[7]

[1] In the Charterhouses, more than in most monasteries, there was no break with the middle ages. In 1601 the prior of Ara Coeli in Portugal had a painting made of Claus Sluter's crucifixion group at Champmol to serve as a model (Monget, p. 280).

[2] *Le Paradis terrestre, ou Emblèmes sacrez de la Solitude.*

[3] The glass was painted with garlands of flowers and cameos of the Desert Fathers.

[4] Guillet de Saint Georges, I, 163.

[5] The pictures of Rome and Paris are now in the Louvre. Piganiol de la Force, VII, 233, says that they were begun in 1649 and finished in 1652. A set of pictures of all the other Charterhouses was made for the Grande-Chartreuse in the seventeenth century. Guillet de Saint Georges, II, 68.

[6] See J. J. Guiffrey, in *Nouvelles Archives* (1877), p. 274.

[7] The pictures, engraved by Chauveau, are described by Guillet de Saint Georges, I, 159: (1) St Bruno as a doctor listens to a sermon by the Canon Diocres. (2) He is present at the Canon's funeral. (3) He hears the corpse thrice admit sin. (4) St Bruno prays at the foot of the crucifix. (5) Instead of lecturing he gives a sermon on penitence. (6) He proposes to leave the world. (7) Three angels appear to him. (8) He and his brother give their goods to the poor. (9) He visits Bishop Hugh at Grenoble. (10) He follows him to the Chartreuse. (11) They build a church there. (12) St Bruno receives the habit from St Hugh. (13) The Order is confirmed at Rome by Pope Victor III. (14) St Bruno gives the habit to his brother. (15) He

From 1630 onwards François Perrier painted a shorter set of pictures of St Bruno's life for the lesser cloister of the Lyons Charterhouse[1] that were clearly meant to rival those at Paris.[2]

About 1683 Claude Audran, Lichery and Stella painted a still shorter series for the Chartreuse de Bourg-Fontaine near Villers-Cotterets.[3] It included St Bruno preaching to the doctors; the saint, as a canon of Rheims, counselling his friends to retire into the wilderness; the Virgin and St Peter appearing to the first Carthusians; and Bruno's canonization. In 1683 his life was painted in grisaille for the choir of the Toulouse Charterhouse by the Toulousain painter François Plaget with a few reminiscences of Le Sueur's pictures. They were completed by a set of the Desert Fathers—Elijah, St John the Baptist, St Paul the Hermit, and the rest, ending in a picture of St Bruno, and were set alternately with plaster reliefs of the Virtues (Plate 70) made by Pierre Lucas in 1749. Further sets were painted by Berinzago and Gonzales in 1771 for Saint-Bruno de Bordeaux and by a local artist for the cloisters at Auray.

Besides these narrative series, the saint was represented in many single pictures, for example one by Mignard from the Val-de-Bénédiction[4] and one by Despax from the Chartreuse of Rodez.[5] Philippe de Champaigne painted the vision of St Bruno for the high altar of the Chartreuse de Gaillon[6] and Sacquespée three pictures for the Carthusians of Rouen.[7] One showed him in prayer with his guardian angel beside him (Plate 71); another showed Carthusians buried in snow receiving communion from an angel (Plate 72); and a third showed the saint saying Mass.[8] Jean Restout painted him in prayer, and in meditation in the desert (Plate 73).[9] J. B. Jouvenet painted St Bruno adoring the Cross (Plate 74) and François Perrier painted him with the Magdalen at the foot of the Cross, offering a lily to the Virgin, for the prior's room at Lyons,[10] and healing the

receives a letter from Pope Urban II ordering him to Rome. (16) He has an audience with the pope. (17) He refuses a mitre. (18) He meditates in Calabria. (19) He meets Count Roger in the wilderness. (20) He appears to him. (21) He dies. (22) He is carried to heaven by angels.

[1] Guillet de Saint Georges, I, 128.

[2] There were ten pictures: (1) St Bruno preparing to renounce the world. (2) Angels appearing to him. (3) St Bruno talking with a hermit. (4) St Hugh lying upon the ground in mortification in his episcopal robes. (5) St Hugh giving Carthusian habits to two followers of St Bruno. (6) The Virgin appearing to St Bruno. (7) The saint and his companions before Urban II. (8) Another vision of the Virgin. (9) The pope offering St Bruno a bishop's mitre and crozier. (10) St Bruno appearing to Roger of Calabria.

[3] Guillet de Saint Georges, II, 20, 67. He says they deliberately made their pictures different from those at Paris.

[4] Now in the Collégiale of Villeneuve-lès-Avignon. A copy of Le Sueur's Death of St Bruno is now in the Museum of Aix-en-Provence, no. 165.

[5] Réau, III, 1, p. 250. Now in the cathedral of Toulouse.

[6] Guillet de Saint Georges, I, 242.

[7] Pointel, I, 244; they are now in the Rouen Museum.

[8] Now in the church of Saint-Nicolas-du-Chardonnet, Paris (Pointel, I, 254).

[9] Roche, p. 82.

[10] Guillet de Saint Georges, I, 140.

sick for the church, where Philippe de Champaigne painted St Bruno and his six companions before a vision of the Virgin for the Chartreuse of Grenoble.[1]

The saint was also represented in sculpture. He appears with Christ and St Bruno over the State of St-Pierre-des-Chartreuse, Toulouse (Plate 75). About 1628 Jacques Sarrazin carved a statue of him in meditation for the church of St-Bruno-des-Chartreux at Lyons[2] (Plate 76). About 1640 Nicolas Legendre carved several statues of him for Gaillon, each differently posed.[3] In 1672 he and St John the Baptist were carved for the north side of the choir at St-Bruno de Bordeaux (Plate 77). On the entrance gate of Le Liget the saint was represented about 1690 on one side of the gate and Christ in the Wilderness on the other. In the eighteenth century St John and St Bruno were again carved, for Villeneuve-lès-Avignon;[4] and a similar pair was carved by Houdon in 1769[5] (Plate 78) and by Chinard for the Chartreuse de Solignac.[6]

The Carthusian St Anthelme was painted by Perrier for the Lyons Charterhouse, raising from the dead a man bitten by a snake,[7] and a painter of the school of Mignard depicted the English Carthusian martyrs under Henry VIII for Villeneuve-lès-Avignon[8] (Plate 79). Royal benefactors were depicted in a series of seventeenth-century pictures from Le Liget.[9]

Nearly all the other pictures and sculptures of the Charterhouses were of scenes of the life of Our Lady (Plate 80) and of Christ (Plate 81), chosen for their appropriateness as themes for meditation.

The exception is a composite scheme designed and executed in stucco by Pierre Lucas for the cloister of the Toulouse house in 1749. It includes twelve bas-reliefs: two larger of the vow of St Charles Borromeo and the Repentance of St Peter, and ten smaller of allegorical compositions of women carrying attributes to symbolize the cardinal, theological and monastic virtues.

[1] Réau, III, 1, p. 252. The picture has disappeared but a drawing for it survives in the Collection Dutuit in the Petit Palais at Paris.

[2] Guillet de Saint Georges, I, 117.

[3] *Ibid.* p. 409.

[4] Now in the church of Saint-Didier, Avignon.

[5] The St Bruno is in S. Maria degli Angeli at Rome; it is not certain if the St John was executed in marble, and its plaster is lost (see *Bull. de la Soc. de l'hist. de l'art français*, 1922, p. 316).

[6] Réau, III, 1, p. 250.

[7] Guillet de Saint Georges, I, 128; Laran, 'Une Vie inédite de François Perrier', *Mélanges offerts à M. Henry Lemonnier* (1913), p. 198.

[8] Mâle, *A.R.C.T.* p. 121. The picture is now in the Museum of the hospice there. It formed part of a series mentioned by Charles de Brosses, *Lettres d'Italie*, Letter 1, 1739.

[9] Now in the Tours Museum.

5

THE CARMELITES

The Carmelites, like other contemplative Orders, knew that to many religions a picture might provide a fit subject for meditation. It is not surprising that such of their chapels as survive are often closely set with paintings (Plate 82).

The Carmelites always regarded Elijah as their founder. There was a great quarrel with the Bollandists in 1675 when their *Acta Sanctorum* for April appeared, stating that the Order dated not from the time of Elijah but from the twelfth century.[1] The quarrel was not settled until in 1727 Pope Benedict XIII allowed them to set up a statue of Elijah in St Peter's as the founder of their Order.

The prophet was represented in Carmelite imagery but, perhaps in consequence of the quarrel, rather less often than might have been expected. The Vaugirard house had statues of Elijah and St Teresa on the high altar,[2] and the dome was painted by the Belgian Bartholet-Flemaël, with the Ascension of Elijah. Pictures of the lives of Elijah[3] and Elisha and of the Triumph of St Teresa by Despax and Rivalz still hang in the Chapelle des Carmes at Toulouse[4] (Plate 83). The Transfiguration of Christ, in which Elijah appeared beside the Saviour, was represented by a sculptured group on the high altar of the Carmelites in the Place Maubert (Plate 84), which also had statues of Elijah and Elisha, and pictures of St Anthony and St Paul the Hermit as his disciples.[5]

St Teresa of Avila, the reformer of the Order, was more often represented. Walther Damery of Liége painted her for the Paris house in 1640.[6] A picture of her vision at Rouen (Plate 85) probably comes from a Carmelite house. In the Paris house there was an altar picture of Christ appearing to her and St John of the Cross;[7] another of him appearing to her alone, by Guercino;[8] pictures of her in prayer and meditation by Le Brun;[9] Christ crowning her in glory;[10] the Holy

[1] Mâle, *A.R.C.T.* p. 445.

[2] Guillet de Saint Georges, I, 414, ascribes them to Nicolas Legendre. A design for a new retable by Oppenord made in 1711 represents the Virgin and Child with the Shepherds, the Presentation in the Temple and the Flight into Egypt (see Vanuxem in *Bull. de la Soc. de l'hist. de l'art français*, 1956, p. 62).

[3] A picture of Elijah's Dream by Philippe de Champaigne of about 1655, now in the Musée du Mans, is said to have come from the Val-de-Grâce, perhaps from the queen's apartments (Royal Academy Exhibition, *Age of Louis XIV*, 1958, no. 137). It would seem to have been more appropriate to a Carmelite house.

[4] Elijah occurs twice in the pictures of the Carmes at Nancy.

[5] Mâle, *A.R.C.T.* p. 449.

[6] Réau, III, 3, p. 1260. A picture of her by P. Mignard now in the church of St-Sébastien, Narbonne, probably came from a Carmelite house (*ibid.*).

[7] See Count A. Doria in *Rev. de l'art*, LXVII (1935), p. 77. Auzas in *Bull. de la soc. de l'hist. de l'art français* (1961), p. 57, shows that it is by J. B. Corneille. [8] Now at Aix-en-Provence.

[9] Jouin, p. 495. [10] Guillet de Saint Georges, I, 11.

Ghost appearing to her as a dove as she writes;[1] and a picture by Nicolas Loir[2] showing the Virgin and St Joseph giving her the white mantle of the Carmelites. Another by J. B. Corneille showed her mystical union with Christ, symbolized by His gift to her of a nail from the Cross.[3]

The Discalced Carmelites of Aix-en-Provence had pictures by Daret of St Teresa receiving a cross from the Virgin and the mantle from St Joseph;[4] another by Guercino of her seeing the vision of the Trinity;[5] and another by Philippe de Champaigne of Christ showing her His wounds[6] (Plate 86). Nantes had one of her in ecstasy,[7] and Amiens one by Rubens of Christ delivering the soul of Prior Bernard de Mendoza from hell at her prayer.[8] A. de Vuez painted her Apotheosis for Lille. The Carmelites in the Place Maubert had a group, over life-size, of the Virgin giving a rosary to a kneeling Carmelite, with St Joseph and St Joachim behind, and St Teresa and St Laura and angels below. In 1726 a feast was instituted in honour of her vision of an angel transfixing her heart with an arrow, and the subject was painted for the Carmelites of Paris[9] (Plate 87).

St Simon Stock was far less popular. Van Oost painted the Virgin giving him the scapular for Lille, N. Mignard portrayed the scene for Aix,[10] and Walther Damery for Paris.[11] Jouvenet painted St John of the Cross kneeling before a picture of the Passion for the Carmelites of Aix,[12] and Walther Damery for the Discalced Carmelites of Paris.[13] There was a statue of St Catherine of Sienna in the church of the Carmelites at Avignon,[14] and two pictures of St Anthony of Padua at Paris.[15] The Blessed Marie de l'Incarnation was painted for Pontoise, with an angel above her head holding a crown of thorns.[16] At Narbonne, there was a picture attributed to Bourdon, of a Carmelite nun giving alms to an old man[17] (Plate 88). The picture has something of the individuality of a portrait. At Rouen[18] there was a picture of Carmelites in a rocky desert performing acts of devotion: one adores a crucifix in a cave, one meditates on a skull, one abases himself before a wooden cross laid on the ground, one flagellates himself, and one has a vision of the Virgin and Child. In 1765 Lépicié painted a picture of St Crispin and St Crispinian giving their goods to the poor, for the Carmelites of Chalon-sur-Saône.[19]

The Carmelites' choice of biblical subjects was naturally influenced by their

[1] By Le Brun (Mâle, *A.R.C.T.* p. 167). It is now in the Carmelite convent of the Avenue de Saxe.

[2] Guillet de Saint Georges, I, 337.

[3] Mâle, *A.R.C.T.* p. 163; now in the church of Saint-Pierre-le-Puellier, at Orleans.

[4] Now in the church of the Madeleine (Pointel, I, 48).

[5] Museum of Aix-en-Provence. [6] In the same Museum.

[7] Now Musée des Beaux Arts, Nantes, no. 981.

[8] A sketch is in the Museum of Amiens, no. 309.

[9] Now in Saint-Nicolas-du-Chardonnet.

[10] Mâle, *A.R.C.T.* p. 450. Now in the church of Saint-Jean-de-Malte.

[11] Réau, III, 3, p. 1226. [12] Now in the Museum of Aix-en-Provence.

[13] Réau, III, 2, p. 734. [14] Now Musée Calvet.

[15] Courajod, *Lenoir*, I, 138. [16] Mariette, III, 65.

[17] Now Narbonne Museum no. 44. [18] Now in the Archevêché.

[19] Diderot, *Salons*, III (1960), 41.

preoccupation with solitary meditation. Christ in the Wilderness[1] (Plate 89) and Christ[2] in the Garden of Gethsemane were obvious themes, as were His Childhood and Passion.[3] Pupils of Philippe de Champaigne painted the raising of Lazarus for the Carmelites in the rue Saint-Jacques at Paris.[4] The Grands-Carmes of Marseilles transformed their late Gothic church in the seventeenth century by installing in its side chapels sculptural compositions of the Adoration of the Magi, the Crucifixion and the Baptism of Christ. The general effect is of an aquarium. No less characteristic are the sculptures of the apostles (Plate 90) by Artus Quellin of Antwerp in the choir of the Carmelites of Lille.

At Paris two statues of the repentant Peter and the weeping Magdalen stood as symbols of penitence and confession,[5] and the Magdalen also appeared in several pictures in Paris,[6] and at Toulouse.[7] The Carmelites shared in the Jesuit cult of St Joseph[8] and had many pictures of him; and had a devotion of their own to the Child Jesus, after a Carmelite nun at Beaune had had visions of Him.[9] On an altar at Pont-l'Abbé the Virgin is sculptured among roses over statues of St Crispin and St Crispinian; at Lectoure she appears in a good picture of the Assumption.

The Paris house had a picture of Christ appearing to the Magdalen, which roused a measure of criticism[10] because He appeared naked. It was felt to be not only, on general grounds, improper, but also, since she mistook Him for the gardener, inappropriate.

The consistency of Carmelite imagery is stressed by the contrast offered by the Estampes Chapel in Saint-Joseph-des-Carmes at Paris. It was a private chapel, and the themes, chosen by the donor, include the lives of St James, St Dominic and St Francis, nowhere else represented in a Carmelite church. Only the Transfiguration links the cycle with Carmelite iconography.

[1] Paris; Guillet de Saint Georges, I, 10.

[2] By Le Brun, Piganiol de la Force, VI, 166; Jouin, p. 470, now Louvre no. 497.

[3] E.g. Michel Corneille's picture of St Joseph and the Child Jesus, at the Grands-Carmes of Orleans (Auzas, in *Bull. de la soc. de l'hist. de l'art français*, 1961, p. 47).

[4] Blunt, pp. 173, 216. They are now at Grenoble. Sir Anthony Blunt thinks it possible that the Adoration of the Shepherds, now in the Wallace Collection, was also painted for them.

[5] Mâle, *A.R.C.T.* p. 68. St Peter and the patron of the church, St Andrew, are represented in sculpture on Saint-André at Lille, built in 1702.

[6] Guillet de Saint Georges, I, 10, 11. One by Le Brun is now Louvre no. 505.

[7] By Jean de Troy, now in Toulouse Museum.

[8] Mâle, *A.R.C.T.* p. 314. The Paris house had a picture of an angel appearing to him (Guillet de Saint Georges, I, 10).

[9] Mâle, *A.R.C.T.* p. 328. A picture from the Paris Carmes by Simon Vouet went to the Louvre in 1792, and it was also painted for the Order by Simon François, Boulanger and Philippe de Champaigne.

[10] E.g. Chanoine de Cordemoy, *Nouveau traité de toute l'architecture* (Paris, 1714), p. 122 (see above, p. 22).

6

THE DOMINICANS

The Order of Friars Preachers had fewer houses and perhaps carried less weight in post-Reformation France than in Spain or Italy, but it maintained the Order's traditionally high standard of scholarship. As centres of preaching to lay congregations, the Dominican churches naturally shared in the iconography common to all Catholics, and had the usual pictures of the Annunciation, Presentation, Transfiguration,[1] Assumption and Passion.[2] Their church at St-Maximin, which held a relic of St Mary Magdalene, had (and has) a number of pictures and sculptures of her (Plate 91), including a terra-cotta relief of St Maximin giving her communion.

St Dominic played a considerable part in Dominican iconography. At the Dominican church of Saint Laurent at Le Puy he is painted praying before a statue of the Virgin. Three medallions above the stalls at Saint-Maximin were carved with scenes from his life by the Dominican Funel (Plate 92), while nearly every one of the twenty altars has a picture bearing some reference to him. His statue appears on the façade of Notre-Dame de Bordeaux, accompanied by his traditional emblem of the dog bearing a torch in its mouth;[3] the central relief is carved with his vision of the Virgin. He hardly ever appears alone. Even on the façade of the Jacobins at Paris he was paired with St Catherine of Sienna.[4] Most often the Virgin gives him the rosary[5] (Plate 93); once at least she appears to him in a vision.[6] Often St Catherine of Sienna is there to receive the rosary too.[7] A picture of the Novitiate General[8] showed the Virgin giving his picture to a Dominican. The Mystic Communion of St Catherine of Sienna was painted by Philippe Quantin for the Dominican nuns of Dijon (Plate 94).

The martyrdom of St Hyacinthe, the Dominican evangelist of Poland, was painted for his chapel at the Novitiate General; the Paris Dominicans also had pictures by Testelin[9] of the saint seeing the Virgin in a vision and walking on the

[1] E.g. the ceiling of the chapel of St Louis, behind the choir of St-Thomas-d'Aquin, Paris, by F. Lemoine, 1724.

[2] E.g. their church of St-Laurent at Le Puy has good pictures of the *Noli me tangere* and the Deposition.

[3] This also accompanies him on a picture in the Rouen Museum, Pointel, I, 261; it figures on the front of Saint Cannat at Marseilles and appears above the altar and on the stalls at Saint Maximin.

[4] 1611. Guillet de Saint Georges, I, 280.

[5] Aix-en-Provence, by Daret; Toulouse, Mâle, *A.R.C.T.* p. 466; Paris, Piganiol de la Force, VIII, 154.

[6] Church of Genilié, Indre-et-Loire.

[7] Mâle, *A.R.C.T.* p. 469; he cites pictures at Beaulieu-sur-Loire, Notre-Dame-de-Bethléem at Ferrières, and Notre-Dame-du-Marthuret at Riom.

[8] Piganiol de la Force, VIII, 154.

[9] Stein, p. 65.

waters. Pictures of four Dominican saints are in the choir of Saint-Laurent at Le Puy; a fifth is in the nave.

When St Rose of Lima and St Louis Bertrand were canonized in 1671, the Paris Jacobins commissioned Antoine Stella to paint them for the church.[1] St Rose was shown carrying the Child Jesus, St Louis with a pistol that was also a crucifix, in memory of the miraculous change that took place when an enemy tried to shoot him. Another picture in the same church[2] showed him half kneeling on clouds, holding a cross. St Rose was also portrayed there, with St Catherine of Sienna and St Dominic presenting her to the Virgin; and at Nantes with an angel pointing to a passage in the Bible for her to read[3] (Plate 95). St Catherine was also painted for he same house,[4] very sentimentally, by Frère Jean André,[5] the Dominican painter (Plate 96).

When Pope Pius V, another Dominican, was beatified in 1676, a picture of him with three angels was painted for the Paris Jacobins, and another for the Novitiate, representing him praying for the success of the battle of Lepanto.[6]

The Dominicans seem to have enjoyed schemes with whole hierarchies of their saints. A picture from Grenoble shows Pope Innocent V with St Dominic, St Thomas Aquinas, St Hugo of Saint-Chef, St Catherine of Sienna, St Rose of Lima and others, with Christ and the Virgin above. Statues of the doctors of the Order, St Dominic, Pope Innocent V, St Hugo of Saint-Chef, Albertus Magnus, St Thomas Aquinas and Pierre de la Palud were set up in the 'Ecoles de Saint Thomas'[7] at Paris. The stalls of Saint-Maximin are carved with nineteen medallions of sainted and beatified Dominicans (Plate 97).

The subject of a picture in the library of the Paris Jacobins does something to reveal the reason for this marshalling of an army of martyrs. It represented[8] St Thomas Aquinas seated on a fountain from which the water of truth gushed out from manya pertures. The fountain was surrounded by religions of all the Orders, come to fill their vessels at the spring. Only a Jesuit in the foreground hesitated. In the rivalry between Dominicans and Jesuits we may, indeed, see a struggle between the medieval and the modern tradition.

[1] Guillet de Saint Georges, I, 427; Mâle, *A.R.C.T.* p. 102.

[2] Guillet de Saint Georges, I, 427.

[3] Musée des Beaux-Arts, Nantes, no. 658.　　　　[4] Musée des Beaux-Arts, Nantes, no. 629.

[5] He painted many pictures for the Paris and Bordeaux houses. His self-portrait, painting a picture of Our Lady of the Rosary, is at Versailles.　　　　[6] Piganiol de la Force, VIII, 141.

[7] Piganiol de la Force, V, 425. The chapter-house at Toulouse was decorated in 1626 for the Seventh Chapter General with portraits of the most illustrious members of the Order.

[8] Stein, p. 67; Lenotre, *Paris révolutionnaire*, p. 290. It is probably in allusion to Dominican learning that the side piers of Notre-Dame de Bordeaux are carved with little angels with books.

7

THE FRANCISCANS

The French Franciscans, it is fair to say, were in decline at the moment of the Reformation. None the less, there was still a measure of vitality, both in the Cordeliers and in the reformed houses that stemmed from the parent Order. Theirs was a long and honourable tradition; it was with reason that the chapter-house of the Paris Franciscans, rebuilt between 1582 and 1606, was adorned with a frieze of portrait heads of the Cardinals, Patriarchs, Generals and Saints of the Order.[1]

In the sixteenth century they favoured scenes of the Last Judgment; one on a gold ground with a black-letter text survives from their house at Troyes,[2] and one was painted by Jacques Dejax for their Poitiers convent in 1586.[3]

St Francis of Assisi was naturally honoured in the houses of his Order, though less frequently in France than in Italy. Georges de la Tour's picture of him in ecstasy (Plate 98) was probably painted for a Franciscan house. A seventeenth-century alabaster statuette of the saint at Avignon[4] probably comes from the Cordeliers; Nicolas Legendre carved both him and St Anthony of Padua in stone for the niches of the choir screen of the Paris house,[5] where a whole series of pictures illustrated his life.[6] They represented him in the desert, giving the scapular to Sainte Reine, preaching, and in prayer. Five scenes of his life were painted for the Franciscans of Sézanne by Claude François, in religion Frère Luc, who died in 1685; and a chapel was painted with his life by Parrocel at the Cordeliers of Avignon.[7] A picture of his Apotheosis by Michel Corneille *fils* is in the church of Saint-Paul-Saint-François at Paris.[8] The martyrdom of his sister St Clare figured among the many pictures of the Paris house.[9]

St Bonaventure was far more popular. The Paris Cordeliers had pictures of him meditating, preaching, saving shipwrecked mariners, in prayer, writing on Faith, being received as a Cardinal, being given the Child Christ by the Virgin, being given a book by Christ, and ascending in clouds. Le Brun painted him for them, discovered in ecstasy by Thomas Aquinas.[10] St John Capistrano more rarely figured in painting. A picture survives[11] (Plate 99) from the Toulouse convent by

[1] Piganiol de la Force, VII, 38. [2] Troyes Museum no. 239.
[3] H. Clouzot, p. 46. It was paired by a picture of the 'souffrances des reprouvez et meschans'.
[4] Musée Calvet, no. 165. [5] Guillet de Saint Georges, I, 414.
[6] Stein, pp. 52, 58.
[7] Charles des Brosses, *Lettres d'Italie*, Letter 2, 1739.
[8] Auzas in *Bull. de la Soc. de l'hist. de l'art français* (1961), p. 52.
[9] See J. J. Guiffrey, 'Inventaire des peintures et sculptures du Couvent des Cordeliers de Paris . . . en 1790', in *Soc. de l'hist. de l'art français, Nouvelles Archives de l'art français*, 2nd ser. II (1880–1), 265.
[10] The picture was engraved; see Mâle, *A.R.C.T.* p. 484. [11] In the Toulouse Museum.

Antoine Rivalz which depicts him showing the standard with the name of Christ which gave John Hunyadi victory over Mahomet II at Belgrade. St Anthony of Padua appeared several times among the pictures of the Paris Cordeliers: offering the Host to an ass, who kneels before it to convert an unbeliever;[1] writing in one picture, and reading in another.[2] The chapel of Sainte-Reine was painted with her miracles at the fountain, and her Assumption, by Le Maire, while a picture of her hung in the nave.[3]

By tradition the Franciscan high altar held a picture or sculpture of Christ or the Virgin. At Beaune it was a sixteenth-century relief of the Adoration of the Magi;[4] at Paris[5] and Bourges[6] an Annunciation, and at Rouen a marble relief of the Agony of Christ.[7] At Parthenay a stone retable[8] showed angels carrying the Casa Santa to Loretto. The Franciscan refectory at Marseilles was appropriately adorned with an enormous picture of the Last Supper by Michel Serre.[9]

An unusual subject is the crucifixion of three Franciscans in Japan, painted by Boucher for a house that cannot now be identified.[10]

By the eighteenth century Franciscan imagery was as impoverished as that of the other Orders. The splendid *boiseries* made by Sureau for the Clermont house in 1736[11] have medallions and trophies of ecclesiastic attributes; and the altar was crowned with a picture of the Adoration of the Magi.

When Francesco Gonzaga tried to reanimate French Franciscanism in the sixteenth century he set up 'Houses of Recollection' to revive the spiritual life of the friars. Like the Franciscans, the houses of the Récollets suffered severely in the Revolution. The Récollets naturally shared in the Franciscan devotions; the painting given to the Récollet house of La Baumette near Angers by Maréchal de Brissac about 1620 included St Bonaventure, St Bernardin of Siena and St Louis of Toulouse. A retable from their chapel at Tournus[12] shows St Anthony of Padua receiving the Child Jesus from the Virgin; a second from the same chapel, by Greuze, shows St Francis in ecstasy.

The Récollets had a patron of their own in St Salvador de Huerta. Their convent at Aix-en-Provence had two pictures of him; one of him healing those possessed of devils, and one, seeing a vision of the Virgin.[13] Their founder, Francesco Gonzaga, appears with St Francis on the façade of their chapel at Saint-Céré in the Lot, built in 1662; beneath the reliefs are niches with statues of St Joseph and St Anne. The Franciscans were *Custodes Terrae Sanctae*, and Récollets in particular

[1] See Mâle, *A.R.C.T.* p. 486. [2] Stein, p. 57. [3] *Ibid.* p. 52.

[4] H. David, *De Sluter à Sambin* (2 vols. Paris, 1932), fig. 60; the relief is now in the Hôtel de Résie at Beaune.

[5] By Le Brun (Guillet de Saint Georges, I, 8).

[6] By Jean Boucher (Pointel, II, 108). [7] Now in the church of Saint-Vivien.

[8] Now in the Caserne de Gendarmerie. [9] Guillet de Saint Georges, II, 246.

[10] Réau, III, 2, p. 291. Now in the Fritz Jung Collection, Berlin.

[11] Now in Saint-Pierre-des-Minimes.

[12] Now in Saint-Philibert; see *Annales de l'Académie de Mâcon*, 3rd ser. x (1905), xxv.

[13] Pointel, I, 51. By Daret; the picture of healing is now in the church of the Madeleine at Aix.

did much to propagate the idea of the Via Crucis and the Stations of the Cross.[1] The Récollets of Toulouse in the mid eighteenth century set up fourteen such stations in the garden of their convent. The women Récollettes of Paris, whose house was in the rue du Bac, owned a picture by Charles de la Fosse of the Child Virgin kneeling on a cloud below the Trinity.[2]

A reform of the observant Franciscans, that renounced the ownership of property not only by its members but also by the houses of the Order, was instituted in Italy in 1520. Its members were called Capuchins from the hoods of their habits. By the middle of the eighteenth century they had four hundred and twenty houses in France.

The Capuchins showed a particular devotion to St Francis in their iconography. Germain Pilon carved a statue of him for the Paris house (Plate 100), wearing the Capuchin habit. He figured with St Anthony of Padua in two great sculptures by Girardon on either side of the statue of Notre Dame de la Paix.[3] The Capuchin church in the rue Saint-Honoré had three pictures of him,[4] including one of him in the desert and one of his death. His death was painted for the Rouen house by Jean Jouvenet[5] (Plate 101). For the Capuchins of the Marais in 1630 Laurent de la Hyre painted a picture—a rather fine night-piece with torches—of Pope Nicholas V having the saint's tomb opened[6] (Plate 102), and the same subject was painted for the Capuchins at Caen by Louis Boullogne,[7] for Rouen by Jean Restout, and by Snelle for Orléans. The saint's miracle of the Portiuncula was painted for the Paris church by Michel Corneille.[8]

The Presentation of the Virgin was represented by pictures both in their Paris church by Le Brun[9] and in their Alençon house[10] by Simon Vouet. The great Paris church was dedicated to the Assumption, and the high altar bore a picture of the subject by Le Brun.[11] Another Assumption was in the Capuchin church of Beaugency.[12] Notre Dame des Anges was painted by Claude Vignon for their Meudon house,[13] and by Antoine Bouzonnet Stella for their high altar at Saint-Amand.[14] A Virgin of Pity was painted by Girodet for their Montpellier house as late as 1788.[15]

[1] Mâle, *A.R.C.T.* p. 494.

[2] Now in the Musée du Havre, no. 181.

[3] Guillet de Saint Georges, I, 322. [4] Stein, p. 69.

[5] Now in the Musée de Rath, Geneva.

[6] Now Louvre no. 456. See Mâle, *A.R.C.T.* p. 480; Blunt, p. 171. He also painted an Adoration of the Shepherds for them, which is now at Rouen.

[7] Guillet de Saint Georges, I, 202. [8] Mâle, *A.R.C.T.* p. 480.

[9] Jouin, p. 470. [10] Now in the Alençon Museum.

[11] Auzas in *Bull. de la Soc. de l'hist. de l'art français* (1961), pp. 51 ff. Is now in the church of Notre-Dame de Beaugency.

[12] The nave also contained pictures of the life of the Virgin; Piganiol de la Force, III, 10. Another Assumption was by La Hyre for their house in the rue Saint-Honoré; Guillet de Saint Georges, I, 107, and Stein, p. 69. A picture of the Virgin hangs over the high altar in their chapel at Compiègne.

[13] Guillet de Saint Georges, I, 278.

[14] *Ibid.* p. 426. [15] A dated sketch survives in the Musée Fabre at Montpellier, no. 573.

Nicolas Quantin painted a picture of Christ crowned with thorns (Plate 103) for the Dijon Capuchins before 1636.[1] Laurent de la Hyre painted a big Crucifixion for their high altar at Fécamp,[2] and a Descent from the Cross for that at Rouen.[3] Poussin painted another for the Blois house and Jean Boucher painted an Ascension for the Capuchins of Bourges.[4]

Unusual saints were represented in their churches by Antonio Botta, to whom the Virgin appeared in 1526 near Savona; his statue was given to their church at Pertuis by Cardinal Barberini in 1653.[5] Poussin painted St Felix of Cantalice for the Toulon house about 1649[6] and Verrio for their church at Toulouse (Plate 104); Jean Jouvenet the martyrdom of St Ovide for the Paris Capucines in 1690[7] (Plate 105): their church held his body brought from a Roman catacomb. On Christmas Eve 1730 the Paris Capuchins exhibited in their church a picture of a martyr of their Order, St Fidele de Simeringue, by Robert.[8] The Capuchins, however, remained more faithful than many Orders to the imagery of the saints; the *boiseries* of their church of Saint-Jean-Saint-François at Paris, set up about 1725, represent medallions of saints in an elegant rocaille framework; and such a little country chapel as Notre-Dame-de-Bon-Secours at Compiègne has statues of St Sebastian and St James. Vien painted four pictures of the life of St Martha for the Capuchins of Tarascon.[9]

The Minimes, an Italian reform of the Franciscans, reached France in 1482. Their rule aimed at the *vita quadragesemalis*, which included a perpetual abstinence from meat. By the eighteenth century the Order had a hundred and fifty houses of men and two of women in France.

Their great Paris church was dedicated to their founder, St François de Paule. The pediment held a bas-relief of Pope Sixtus IV, accompanied by prelates and Cardinals, ordering the saint to go to France.[10] A marble statue of the founder[11] stood on one side of the altar to balance the Virgin on the other, and he appeared with the Virgin at the foot of the cross in the stained glass of the church.[12] The picture behind the high altar was changed four times a year: a Descent from the Cross, an Assumption of the Virgin, a Presentation of Christ in the Temple, were succeeded by an Assumption of St François de Paule by Barnoud.[13] Another picture showed him kneeling before the Holy Family. In his chapel there were nine

[1] Pointel, III, 13. It is now in the Dijon Museum.

[2] Guillet de Saint Georges, I, 107; Mariette, III, 45.

[3] Mariette, III, 45. Another was painted by Jean Jouvenet for the Paris house in 1697; it is now in the Louvre. [4] Pointel, II, 109.

[5] Now in the church of Saint-Nicolas.

[6] Now in the church of Sainte-Marie-Majeure, Toulon (Auguier, p. 20).

[7] Now Grenoble Museum no. 50. [8] Piganiol de la Force, III, 10.

[9] Réau, III, 2, p. 894. Now in the church of Ste-Marthe at Tarascon.

[10] Piganiol de la Force, IV, 440.

[11] By Gilles Guérin. [12] Stein, p. 95.

[13] *Ibid.* p. 94. There were also two pictures of St François de Paule in the sanctuary, one holding a lily and one in prayer before Christ.

pictures of his miracles and death, and a larger picture of him resuscitating a child, by Simon Vouet and members of his school.[1] In the sacristy were pictures of two of his miracles, showing him walking on the sea and healing the plague-stricken, and a third of him predicting the death of Louis XI, by 'Dumont, le Romain'. In the Committee room was another picture of him blessing children, and two portraits of him.[2] The Minimes' house at Vincennes had a portrait of St François de Paule together with pictures of St Thomas Aquinas, St Anthony of Padua and St Bonaventure.[3] At Toulon there is a statuette of him and a picture of his death by J. B. Vanloo.[4] His triumph was painted by Fayet on the ceiling of the Minimes' sacristy at Toulouse, and a whole series of his life for the cloister of the Minimes at Lyons.[5] The institution of the Order was painted for the refectory at Paris[6] and an emblematic picture of their four vows for the Minimes of Plessis-lès-Tours, by Jérémie Le Pileur about 1636. Poverty is shown with a heap of gold at her feet; Chastity with a lily; Obedience receiving a girdle from Heaven; and Abstinence bearing a plate of fishes, to represent their fourth vow of a Lenten abstinence all the year.[7] Other cycles of his life were painted for Amboise[8] and Perpignan.[9]

St Francis of Assisi appeared more rarely. He was shown in adoration in a picture in the Vincennes sacristy[10] and in another in the sanctuary; and a picture of his death, after Van Dyck, hung in a chapel of the Paris church.[11] St Anthony of Padua was in the sanctuary at Paris,[12] and St Charles Borromeo in a chapel.[13]

The remaining pictures in the churches of the Minimes were usually of biblical subjects;[14] an instance is a Dream of St Joseph by Philippe be Champaigne, lately acquired by the National Gallery (Plate 106), and a Visitation, after Mignard, at Saint-Pol-de-Léon.[15] Exceptionally, they were combined into an appropriate scheme. The Minimes of Chaillot had their windows about 1578 filled with glass painted with scenes of persecution: Cain and Abel and other Old Testament subjects, the death of St John Baptist, and modern martyrdoms.[16] The Vincennes

[1] Stein, p. 94; Réau, III, I, p. 537.

[2] Stein, p. 92.

[3] *Ibid.* p. 49.

[4] Réau, III, I, p. 537. Now in the Musée de Toulon.

[5] Mâle, *A.R.C.T.* p. 498. Mariette, III, 86, says they were by Louis le Blanc.

[6] *Ibid.* III, 46.

[7] Now in Notre-Dame-la-Riche; Mâle, *A.R.C.T.* p. 498; Réau, III, I, p. 537.

[8] A picture of the saint being received by the Dauphin at Amboise in 1482 survives in the church of St-Denis-Hors at Amboise (Réau, III, I, p. 537).

[9] Réau, III, I, p. 537. A statue of St François de Paule by Louis Génerès, 1657, from the retable is now in the cathedral of Perpignan.

[10] Stein, p. 47.

[11] *Ibid.* p. 95.

[12] *Ibid.* p. 48.

[13] *Ibid.* p. 95.

[14] A Last Judgment by Jean Cousin from Vincennes is in the Louvre; a Death of Ananias and Sapphira from Rouen is in Saint-Nicolas-du-Chardonnet, Paris; and an Adoration of the Shepherds by Nicolas Quantin in the Museum of Dijon.

[15] (Auzas, p. 28).

[16] See A. L. Millin, *Antiquités Nationales* (5 vols. Paris, 1790), III.

refectory had its windows filled with glass, perhaps by the same painter, with scenes of feasting: the banquet of Herod, the feast of Dives, the feast of Antiochus, the feast of the Pharisees, Adam and Eve in Paradise, and the supper at Emmaus,[1] that turned the temptations of the *Vita quadregesemalis* into sermons.

The women Franciscans have left few, if any, recognizable pictures. The house of the Filles de l'Ave Maria at Paris had statues of St Clare and St Louis over the great door.[2] Above was a bas-relief of the Annunciation; the pediment held a statue of God the Father. On the under side of the portal were statues of the Virgin and Child, and of Louis XI and Charlotte of Savoy, who had founded the house in 1471, by F. B. Masson.

Too little remains of Clarisse pictures to reveal much of their iconography; their devotion to St Clare is attested by a picture from their Marseilles house[3] of her bearing the monstrance with the sight of which she drove out the Saracens who were invading her cloister.

The small medieval Order of the Annonciades also came under Franciscan jurisdiction. Their nuns at Bourges had a picture painted for them in 1626 by Jean Boucher of that city, representing the Sacred Heart blessed by God the Father, and adored by their foundress, Ste Jeanne de France, and her confessor, Père Gabriel Maria.[4]

Besides the secular Third Order of St Francis, which is believed to date from the Saint's lifetime, a regular Third Order arose towards the end of the thirteenth century and was established in France by the end of the middle ages. Its few French houses were reformed about 1592; by the middle of the eighteenth century there were fifty-nine convents of men and five of women.

Their house at Picpus, founded about 1600 and dedicated to Notre Dame de Grâce, has vanished, but the records of its pictures give some idea of Third Order iconography. Over the outer door was a statue of the Virgin with St Louis and St Francis on either side.[5] The pulpit was ornamented with bas-reliefs of St Jerome, St Gregory, St Ambrose, St Augustine, and Christ preaching.[6] Over the high altar was a picture of the Adoration of the Magi. The elaborate confessionals of the nave were surmounted by statues.

The refectory was particularly rich in its decoration.[7] It had twenty-four plaster bas-reliefs representing the founders of the religious Orders: Christ with the orb of the world; St John the Baptist; Elijah; St Anthony the Hermit; St Basil; St Augustine; St Odo and two other Cluniac abbots; St Benedict; St Romuald for the Camaldolese; St Norbert for the Premonstratensians; St Bernard; St Dominic; St Joan Amarta, the founder of the Trinitarians; St François de Paule; St Ignatius, and others. St Francis of Assisi was shown giving the Rule of the Third Order to

[1] Stein, p. 48.

[2] Piganiol de la Force, IV, 285. They were carved by Thomas Renaudin in 1660.

[3] Guillet de Saint Georges, II, 246; Mâle, *A.R.C.T.* p. 489.

[4] Lossky in *Bull. de la Soc. de l'hist. de l'art français* (1959), p. 109; now in the Bourges Museum.

[5] Stein, p. 39. [6] *Ibid.* p. 38. [7] *Ibid.* p. 37.

St Louis and St Elisabeth of Hungary, who had belonged to the secular community. It also had a mural painting of the Brazen Serpent by Le Brun.[1]

The cloister had reliefs of the Flight into Egypt and the Virgin and Child, and a carving of the head of St Francis upheld by children.[2] In the garden a grotto held a life-size figure of St Francis receiving the stigmata, with a disciple staunching his wounds; it was attributed to the Franciscan Frère Blaise, said to have been a pupil of Germain Pilon. Another grotto showed Christ in the Garden of Gethsemane, and a third represented Calvary.

[1] Guillet de Saint Georges, I, 9; Jouin, p. 461. [2] Stein, p. 39.

8

THE JESUITS

The greatest Order of the Counter-Reformation was that of the Society of Jesus. From the first the aims of the Society were complex. On the one hand its members followed St Ignatius Loyola in the pursuit of the imitation of Christ; on the other they served the world as preachers, teachers and evangelists.

Both as men devoted to spiritual exercises and as teachers the French Jesuits made much use of pictures. Their interest in the subject was fostered by Louis Richeome,[1] a Frenchman born in 1544, who became a Jesuit in Rome at the Novitiate of S. Andrea al Quirinale. In 1601 he published in Paris a book entitled *La peinture spirituelle ou l'art d'admirer, aimer et louer Dieu en toutes ses œuvres et tirer de toutes profit salutaire*. It was dedicated to the Queen. 'Il n'y a rien', he declared,[2] 'qui plus délecte et qui fasse plus suavement glisser une chose dans l'âme que la peinture, ni qui plus profondément la grave en la mémoire, ni qui plus efficacement pousse la volonté pour lui donner branle et l'émouvoir avec énergie.'

First he takes the reader through all the pictures in S. Andrea and in the neighbouring church of S. Vitale, and then guides him among the birds and flowers of the Novitiate garden.

N'avez vous jamais admiré la figure des glaïeuls violets quand ils sont épanis? Avez vous considéré la posture de leurs feuilles dont trois alternativement courbés en arcade et jointes à la pointe, et trois autres, recourbées et couchées alternativement aussi vers la tige, faisant trois espaces vides, représentant une couronne impériale? Avez vous contemplé le velours violet de celles qui se courbent avec les petites bioches rangées en long sur le mitan comme ouvrage de frise ou canatil?

His next book, *Tableaux sacrez des figures mystiques du très auguste sacrifice et Sacrement de l'Eucharistie*, published at Paris in 1604, is much less original. Instead of the passionate observation of nature we have a book of emblems of a usual kind. Fourteen engravings of such subjects as the Earthly Paradise, the Tree of Life, Melchisidech, Abraham, the Paschal Lamb, and so on, are accompanied by lengthy expositions that read like sermons. They indicate, however, the kind of moral lesson that the Jesuits drew from pictures, and the kind of mystical meditation that they used them to inspire.[3]

At certain seasons, indeed, the Jesuits used to show an emblematic picture called an *énigme* in their churches, to provide a theme and illustration for a sermon and for subsequent meditation. Guillet de Saint Georges[4] records 'plusieurs sujets

[1] See Brémond, I, 32. [2] P. 7.

[3] I had hoped that the book by the Jesuit father A. Possevin published at Lyons in 1594 under the title *Tractatio de Poesi et Pictura* might be interesting, but it proved to be a literary exercise designed to show off his classical accomplishments. [4] I, 223.

d'énigme' in the Jesuit college in the rue Saint-Jacques at Paris, and also states[1] that Claude Vignon painted a number of such pictures for their colleges at Paris, Moulins, La Flèche and elsewhere. In one or two cases he records the subject, usually biblical. In 1699, for example,[2] Nicolas de Plate-Montagne painted 'une énigme pour les RR. PP. Jésuites à Orléans, représentant la Vision de Samuel'. Early in his career Le Brun painted an 'énigme', for the Paris house, of Tomyrus plunging the head of Cyrus into a basin of blood—a strange scene symbolizing the Passion, taken straight from the *Speculum humanae salvationis*.[3]

The practice continued into the eighteenth century. Guillet de Saint Georges mentions[4] a picture of 'Débora entonnant son cantique, tableau fait pour M. le marquis de Florensac à l'occasion de l'énigme des Jésuites de Paris, en l'année 1707'. Its gift by a private person suggests a parallel with the *palinod* of the medieval Puy Notre Dame at Amiens.[5]

The 'énigme' seems to have been shown to the public only at one season of the year. In the same way the French Jesuits of the Maison Professe at Paris changed the picture on their high altar according to the liturgical season. Claude Vignon painted one of the Resurrection for Eastertide,[6] and Philippe de Champaigne another[7] of Christ delivering souls from purgatory, which we are told was only shown at certain seasons. A third picture that appeared on the high altar from time to time was Simon Vouet's Apotheosis of St Louis: the church was dedicated to him.[8]

The splendid royal foundations of Jesuit houses seem to have encouraged such narrative imagery less than the representation of abstract themes. At La Flèche, founded by Henri IV, the chapel, built between 1607 and 1621, has statues of the four Cardinal Virtues in the transept, and emblematic figures in the spandrels of the arcade. At Blois, founded by Gaston d'Orléans, the church, designed in 1624, has in one arm of the transept statues of the theological virtues, with Charity, which once held the founder's heart, and in the other Prayer, with book and censer, Love with a flame on an altar, and Religion.[9] At Rouen the Jesuit chapel has emblematic figures in the manner of the Gesù at Rome (Plate 107 *a* and *b*).

In every Jesuit church a feature was the monumental retables of the altars; splendid series survive at Rouen and Chaumont (Plate 108).

The Gesù at Rome had a picture of the Circumcision on the high altar, since it was on the day of the Circumcision that Christ received the name Jesus, and the feast was the chief one in the Jesuit calendar.[10] The same subject appears over the

[1] Guillet de Saint Georges I, 278. [2] I, 352.

[3] Mâle, *A.R.C.T.* p. 343. A picture of the same subject is in the Museum of Riom. The Lycée at Tournon preserves a picture which I believe to have been an 'énigme' though I cannot explain it.

[4] II, 304.

[5] See Joan Evans, *Art in Mediaeval France* (Oxford, 1948), p. 237.

[6] Guillet de Saint Georges, I, 275. [7] *Ibid.* p. 243.

[8] Mâle, *A.R.C.T.* p. 343; Piganiol de la Force, V, 6. Sauval says the figure of St Louis was so feminine that the picture was sometimes taken for an Assumption of the Virgin.

[9] All are by the sculptor Gaspard Ambert. [10] Mâle, *A.R.C.T.* p. 431.

high altar at Poitiers in a picture painted by Finsonius in 1615. In 1641 Richelieu gave a picture of the Presentation in the Temple by Simon Vouet for the high altar of the Paris Novitiate.[1] The rich retable at La Flèche frames a picture of the Annunciation. In the church of St-François-Régis at Le Puy there is a Crucifixion between statues of St Francis Regis and St Ignatius, with God the Father over the picture, all in gilt wood. The Jesuit churches naturally shared in the Catholic heritage of pictures of the life of Christ[2] and of the Virgin[3] (Plate 109), and of the Evangelists and Apostles.[4] Sometimes they were given an unusual devotional twist; in 1641, for example, Cardinal Richelieu gave the Paris Novitiate a picture by Vouet for the high altar of the *Nunc Dimittis*. Simeon, holding the Child Jesus, takes a sword from the Virgin and turns it to pierce his own heart.[5]

Because of their enjoyment of royal patronage, the French Jesuits often showed pictures of St Louis; the Maison Professe at Paris, as has been said, had his apotheosis as one of the pictures hung from time to time at their high altar. Others adorned Jesuit churches at Lyons, Aix-en-Provence[6] and Poitiers; one survives at Rouen (Plate 110). The Paris house[7] also owned pictures of him in prayer, setting sail for the East, receiving the Crown of Thorns from Christ, receiving the Viaticum, and sending the Jesuits the model of the Church of Christ in answer to the prayer of Louis XIII. A picture now at Tours (Plate 111) shows him tending the sick. The college at Poitiers, which was under royal protection, had two pictures of St Louis, one with the features of Louis XIII and one with those of Louis XIV. Sometimes these pictures may have commemorated a royal benefaction; but it seems as if at other times the royal saint figured as an emblem of the devotion to the monarch of the Society of Jesus: a devotion not seldom impugned by its enemies.

Like all religious Orders the Jesuits liked to portray their founder and the saints of their own Society: St Ignatius Loyola, St Francis Xavier, St Francis Borgia, St Louis Gonzaga, and St Stanislas Kostka.[8] St Ignatius appeared alone rather seldom;

[1] Now Louvre no. 971. Two are now in the Rheims Museum, one by Jean Tisserand, no. 501, and one by Jacques Marmotte, no. 359.

[2] E.g. Adoration of Magi by Claude Vignon, Moulins, and by Reynard Levieux, Aix-en-Provence, now in the church of La Charité at Aix; Christ bound, by Le Brun, Maison Professe, Paris (Jouin, p. 472); the Adoration of the Shepherds at Le Puy, in sheep-farming country. A cycle of the life of Christ is painted on the ceiling and upper walls of the sacristy at Poitiers, 1665–6, and forms the subject of a set of seventeenth-century tapestries with Jesuit emblems in the borders, at Tournon.

[3] E.g. Annunciation and Visitation, by Pierre Puget, Aix-en-Provence (Mariette IV, 223); Annunciation, by Philippe de Champaigne, Novitiate, Paris (Guillet de Saint Georges, I, 241); Assumption, *ibid.* Réau, II, 2, p. 119, mentions a picture of the Virgin protecting the Order.

[4] St John the Divine, by Le Brun, Beauvais (Guillet de Saint Georges, I, 9); Martyrdom of St Peter and St Paul, by Jean Boucher of Bourges, now in the church of Saint-Bonnet; by Claude Vignon, Maison Professe, Paris (Guillet de Saint Georges, I, 275); Angel delivering St Peter from prison, Maison Professe (Guillet de Saint Georges, I, 243).

[5] Réau, II, 2, p. 265. Now in the Louvre.

[6] It is now in the church of the Madeleine there.　　　　　　　　　　　　[7] Stein, p. 120.

[8] The well-known effigy of him on his death-bed at S. Andrea al Quirinale at Rome does not seem to have been copied in France.

the Paris church had a picture of him by Le Brun,[1] after Boullogne, and another by Claude Vignon showed Christ appearing to him. His chapel, instead of an altar picture, had a bronze crucifix with the figure of the Saint kneeling before it.[2] At the Novitiate there was a statue of him by Guillaume II Coustou[3] and a picture of the Virgin appearing to him by Mignard;[4] at Orleans one by Michel Corneille;[5] the same subject is represented in one of the transept chapels at Le Puy. A picture of his Triumph by Claude Vignon, now in the Orleans Museum,[6] must have come from a Jesuit house.

St Ignatius and St Francis Xavier were far more often figured together. Statues of them both were on either side of the high altar of the Jesuit Novitiate at Paris; pictures of their triumphs, in two chariots, pushed by the Virtues, were in the gallery;[7] statues of them stood over the sacristy door of the Maison Professe;[8] and pictures of them adorn the charming sacristy at Poitiers and once decorated the refectory at Rheims. They appear on either side the crucifix in a picture by Guy François du Puys from the college at Montpellier.[9]

St Francis Xavier appears alone fairly frequently. The Novitiate at Paris was dedicated to him, and had famous pictures by Poussin[10] of him resuscitating a dead man in India, a subject described in his bull of canonization in 1622, and recalling to life a Japanese girl (Plate 112). Michel Corneille painted for them a picture of him taking Faith to the Indies.[11] In 1744 his apotheosis was sculptured by Guillaume Coustou for the Jesuit church of Saint-Paul de Bordeaux (Plate 113).

On a few occasions a whole hierarchy of Jesuit saints were portrayed together. Antoine Bouzonnet Stella painted a large picture for the Jesuits of Châlons-sur-Marne[12] with Christ at the top surrounded by the saints of the Order, with allegorical figures below of the four quarters of the world that they had evangelized. Sculptured medallions were set inside the Jesuit church at Cambrai in 1692 with St Ignatius, St Francis Xavier, St Francis Borgia, the four martyrs of Japan, St Stanislas Kostka and St Louis Gonzaga. Eight medallions and four full-length figures of Jesuit saints are painted round the apse of the Jesuit church at Le Puy.

[1] Jouin, p. 490. [2] Piganiol de la Force, v, 11.

[3] Now in the church of Saint-Germain-des-Prés.

[4] Guillet de Saint Georges, I, 241.

[5] Auzas in *Bull. de la Soc. de l'hist. de l'art français* (1901), p. 47.

[6] Réau, III, 2, p. 675.

[7] Guillet de Saint Georges, I, 275; Piganiol de la Force, v, 424, by Claude Vignon. That of the Triumph of St Ignatius may be that mentioned above.

[8] Piganiol de la Force, v, 76.

[9] Now in the Montpellier Museum. A picture in the second chapel to the left of Saint-Nicolas-du-Chardonnet at Paris shows them interceding for sinners whom angels are plunging into a furnace; it probably comes from a Jesuit church. A similar picture is in the Toulouse Museum.

[10] Now in the Louvre (see Mâle, *A.R.C.T.* p. 100).

[11] Stein, p. 120.

[12] Guillet de Saint Georges, I, 426; Mâle, *A.R.C.T.* p. 443. It was earlier than the similar scheme in S. Ignazio at Rome.

When the Jesuit Laugier's book, *Manière de bien juger les ouvrages de peinture*, was posthumously published in 1771, the glories of Jesuit art in France were at an end. He has nothing very new to say; he pleads for skilfully composed pictures addressed to a well-educated public and teaching a moral lesson; and, perhaps remembering Richeome, demands the careful study of trees and ground.

9

LESSER ORDERS

A number of minor medieval Orders survived the troubled times of the sixteenth century. Some of their pictures in turn survived the Revolution, though it is easy to suppose that the source of comparatively few has been identified. The Mercedarians, for example, were an Order devoted to the ransom of prisoners; two pictures from their house went to the Louvre in 1792: a *Repos en Egypte* by Boullogne and a *Prise d'habit* by Bourdon. Where are they now? The Order, in fact, had a minor iconography of its own: the altar of the Paris house[1] was adorned with statues of the Mercedarian saints, St Pierre Nolasque and St Raymond de Pennafort, which were considered to be the masterpieces of Michel Anguier. Sébastien Bourdon painted a picture of Pierre Nolasque receiving the Jesuit habit.[2] Their rivals in the ransom of prisoners, the Mathurins, had a picture over the high altar of their Paris house[3] of the Trinity, with a group above it with an angel holding the chains of two prisoners—the vision that appeared to the founder, St Jean de Matha, when he first said Mass. The walls were painted with scenes of his life and of that of his colleague St Félix de Valois. The Mathurins also had pictures by Claude Vignon of St John the Evangelist and St Charlemagne.[4] They also had a picture of the Virgin wearing the scapular of their Order that evoked criticism from an Augustinian.[5]

The Order of Antonins, with a mother house at Saint-Antoine in the Dauphiné, has left a few pictures as memorials of its existence. An admirable portrait of a brother of the Order by Guillaume Voiriot, now in the Dijon Museum,[6] shows him with a plan of the mother house. Various pictures from it are in the Museum of Grenoble: St Jerome by Georges de la Tour[7] (Plate 114); a moonlight scene of St Nicholas giving alms;[8] a death of St Anthony, surrounded by his monks, attributed to Parrocel[9] (Plate 115); and pictures of Rachel with Jacob's messengers, and Christ and the Samaritan woman, by Jacques Stella.[10]

The church still contains six large pictures of the life of St Anthony painted by Marc Chabry in 1690: a Crucifixion with saints and Anne of Austria holding her

[1] Piganiol de la Force, IV, 329.

[2] Réau, III, 3, p. 1102. Now in the church of Saint-Germain-l'Auxerrois at Paris.

[3] Mâle, *A.R.C.T.* p. 496. An engraving of it made in 1647 is in the Bib. Nat. Estampes Hd 193. The elaborate composition also included two saints of the Order, the Emperor Constantine and St Matthew, and statues of a Turk and a captive.

[4] Guillet de Saint Georges, I, 275.

[5] Chanoine de Cordemoy, *Nouveau Traité de toute l'architecture* (Paris, 1714), p. 122.

[6] No. 129.

[7] A variant, now in Stockholm, shows the saint carrying a scourge for flagellation (Réau, III, 2, p. 742).

[8] No. 46. [9] No. 84. [10] Nos. 98 and 99.

son, painted in 1638 by Père Michel Manière, a brother of the abbey; and a number of copies from Italian pictures of sacred subjects.

The house of the Order of Malta at Aix-en-Provence had a relief by Christophe Veyrier of Christ sleeping upon a cross.[1]

A picture by Jean Jouvenet of Christ at the house of Martha and Mary remains from the Paris house of the Pères de Nazareth in the rue du Temple[2] (Plate 116); they also had some terra-cotta figures of St Peter and St Paul and a seated Virgin.[3] The Paris Theatines had a number of pictures of St Gaetano, their founder.[4]

The numerous lesser Orders of women have left fewer memorials. Of the Dames de la Miséricorde, installed in the rue du Vieux Colombier at Paris in 1651, we know little but that its altar-piece was a much-admired picture of Our Lady of the Seven Sorrows, and that one of its chapels contained a picture of St Anthony by Blanchard.[5] The Dames Hospitalières de Ste Catherine at Paris had a statue of their patroness carved for their portal in 1704.[6] The Union Chrétienne is represented by a picture of God the Father appearing to a group of nuns in white habits with black veils and cloaks now in the Museum of Tours.[7]

Without doubt much remains to be identified. Not all was destroyed at the Revolution; many pictures were sent, with little indication of their origin, to the new national repositories of art. Most remain there, or in the later Museums that succeeded them. The devoted labours of their curators are beginning to bring their history to light; people begin to be interested in knowing for whom and why the pictures now in galleries were painted.

Yet, though these pictures and statues survive, it must not be forgotten how completely the Revolution cut in two the tradition of monastic iconography. Not only the structure of artistic patronage, but also the subject matter of the painter, was utterly destroyed. The sculptor Houdon, at the moment of the Revolution, retouched an old Scholastica.[8] He was denounced by the Convention and saved himself only by turning her into a statue of Philosophy.

[1] Réau, II, 2, p. 286. [2] Louvre no. 432. [3] Stein, p. 35.
[4] Guillet de Saint Georges, II, 15; Stein, p. 72.
[5] Sent to the Louvre in 1792 (Lossky, p. 114). On their devotion to the Sacré Cœur see Lossky, p. 110.
[6] By Regnaudin, Réau, III, 1, p. 26.
[7] No. 104; by Charles Lamy, 1735.
[8] Also in the Museum of Tours, Lossky, p. 111. Another version is still in the possession of the surviving house of the Order at La Rochelle.

PLATES

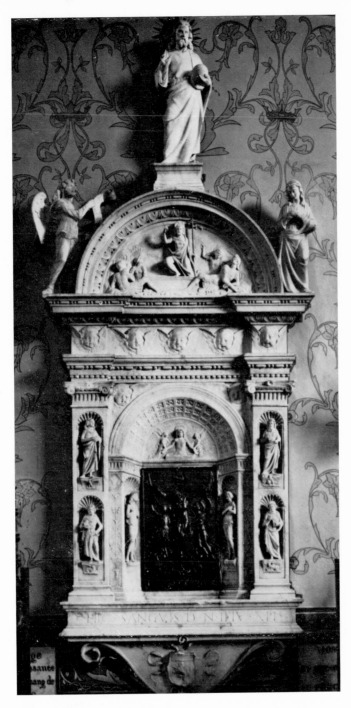

1 Tabernacle of the Precious Blood. (Pace Gaggini, 1507.) From the
Benedictine abbey of La Trinité, Fécamp, Seine-Maritime.

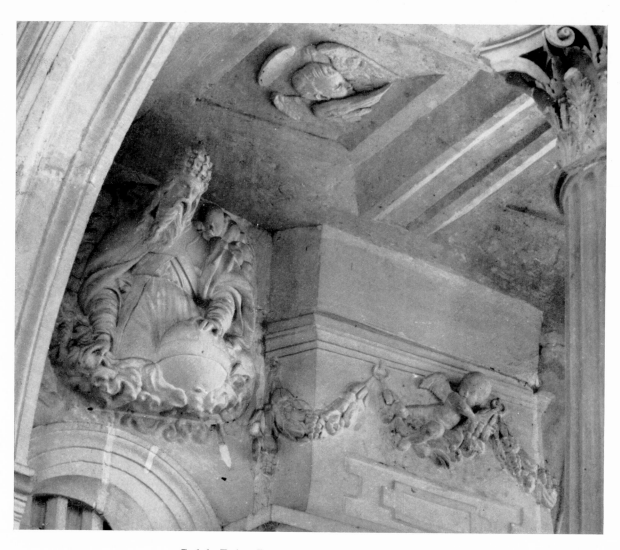

2 God the Father. From the Lady Chapel of the Benedictine
abbey of Valmont, Seine-Maritime. (1517–52.)

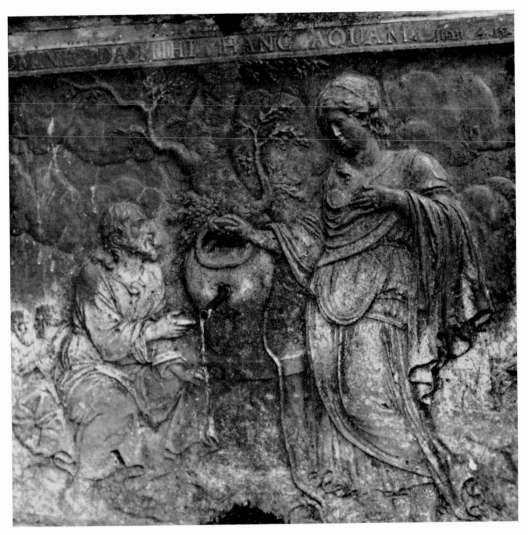

3 Fountain relief of Christ and the woman of Samaria. (*c.* 1700.)
From the Benedictine abbey of Saint-Seine-l'Abbaye, Côte d'Or.

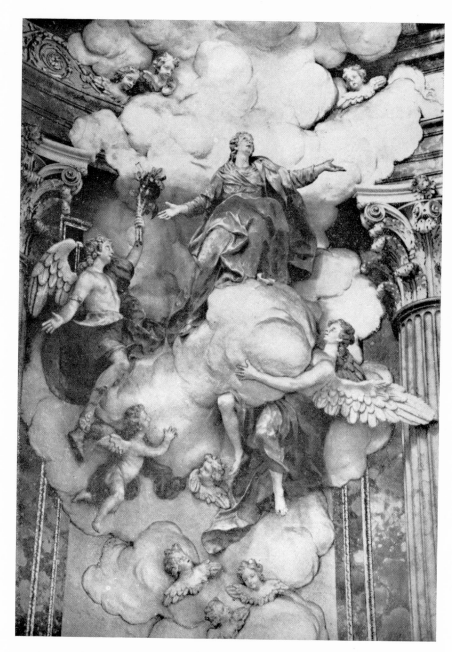

4 The Assumption. (Schnorrer, *c.* 1700.) Detail of retable, from the
Benedictine nunnery of Notre-Dame, Guebwiller.

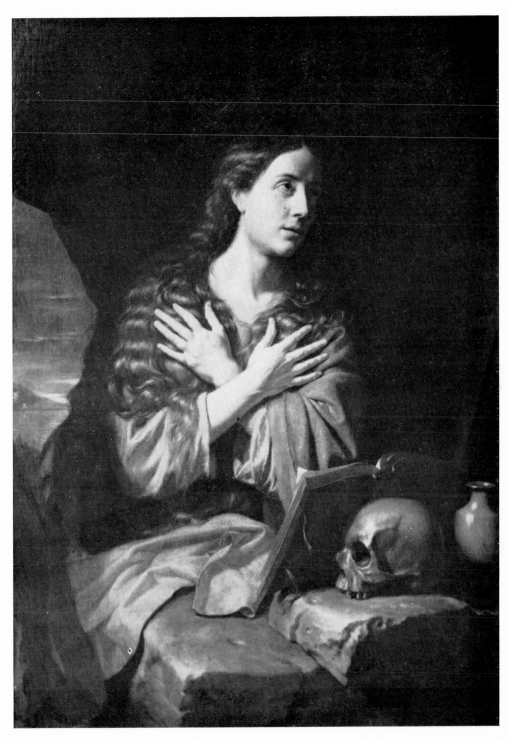

5 The Magdalen. (Philippe de Champaigne, 1657.) From the
Benedictine nunnery of Saint-Melaine.

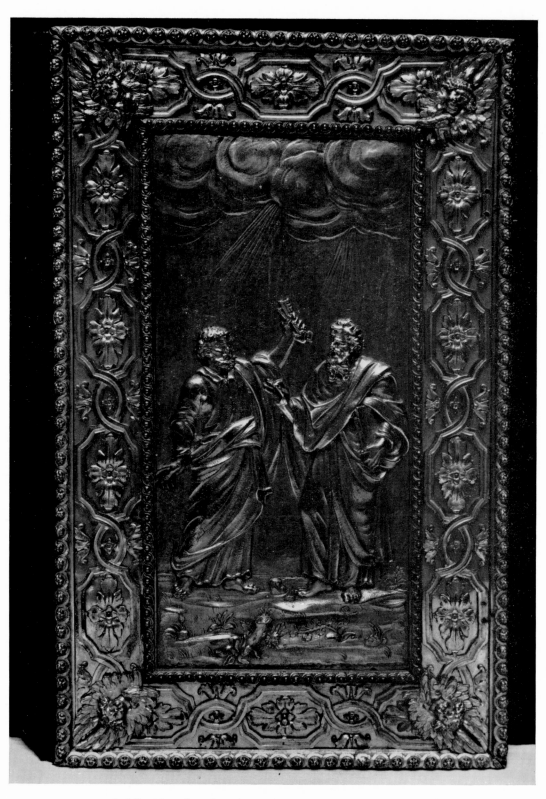

6 Missal bound in gilt copper. (Second half of seventeenth century.)
From the Benedictine abbey of Saint-Riquier.

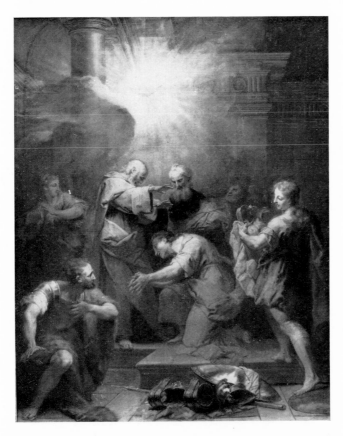

7 Paul and Ananias. (Jean Restout.) From the Benedictine
abbey of Saint-Germain-des-Prés, Paris.

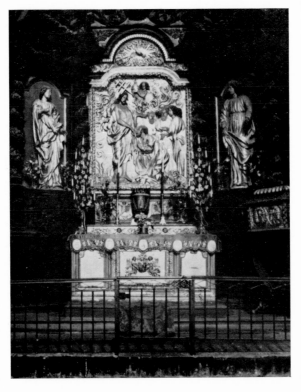

8 Christ giving the keys to St Peter. (*c.* 1630.) Gilt-wood retable,
from the Benedictine (Cluniac) priory of Beaulieu.

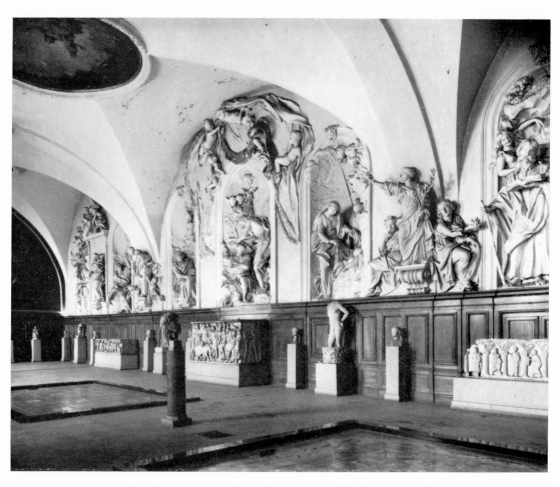

9 Benedictine nunnery of Saint-Pierre de Lyon. The Refectory. (1681.)

10 Adoration of the Child Christ. (? Michel Anguier, 1665.) Maquette of the sculpture made for the
Benedictine nunnery of Le Val-de-Grâce, Paris.

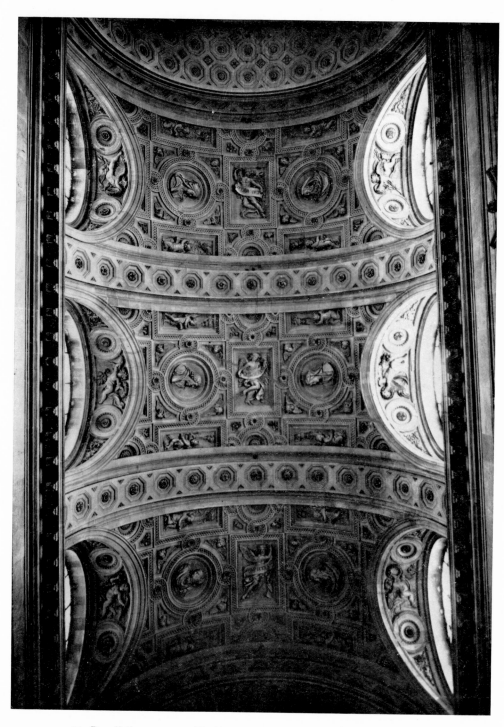

11 Benedictine nunnery of Le Val-de-Grâce, Paris. Vault of the nave. (1645.)

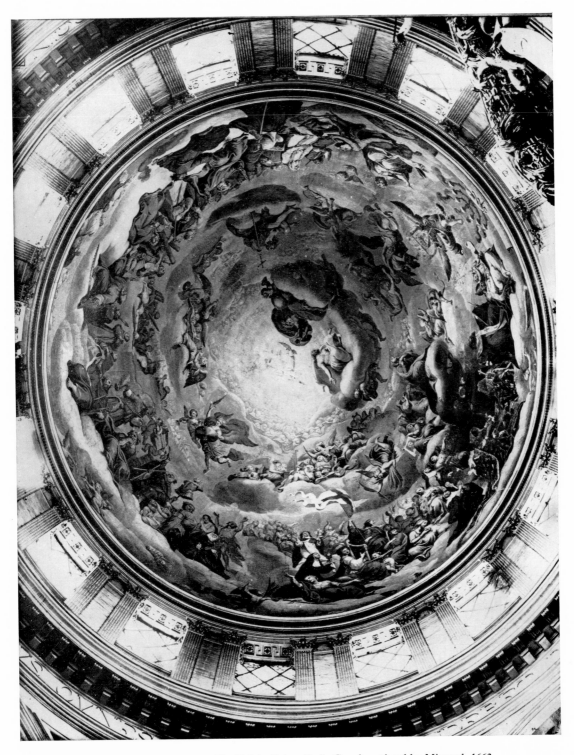

12 Benedictine nunnery of Le Val-de-Grâce, Paris. Cupola, painted by Mignard, 1663.

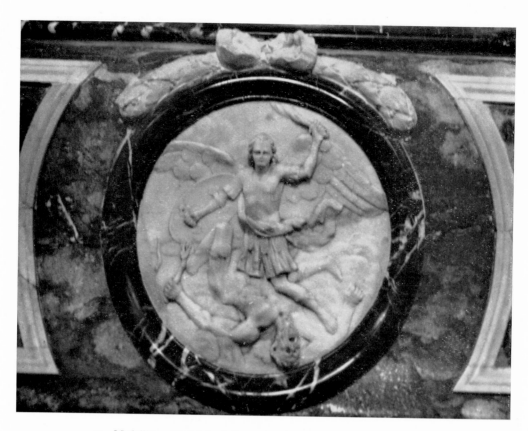

13 Medallion of St Michael. From the altar of the Benedictine abbey of
Saint-Michel-en-l'Herm, Vendée.

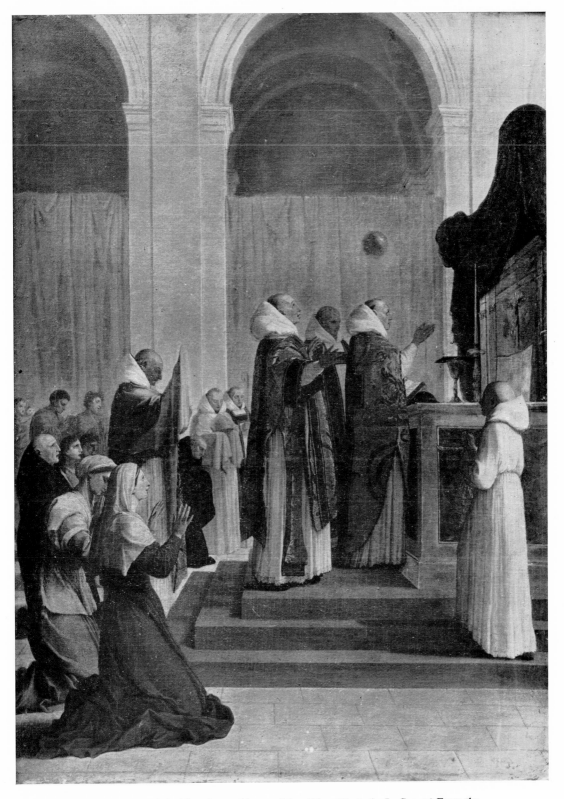

14 St Martin beholding the world as a globe of fire. (Eustache Le Sueur.) From the
Benedictine abbey of Marmoutier.

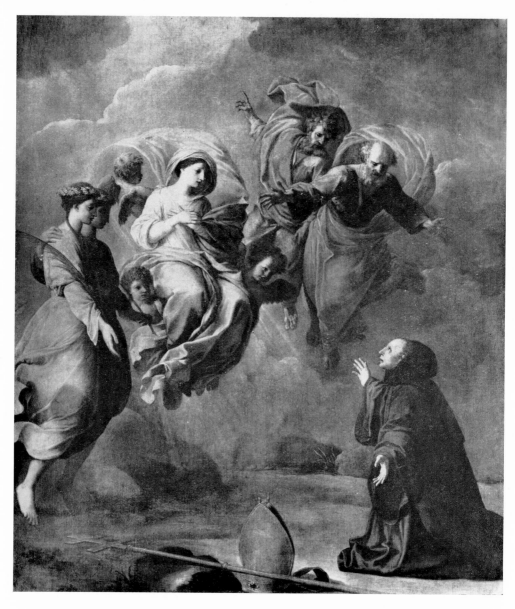

15 The Virgin accompanied by St Agnes, St Thecla, St Peter and St Paul appearing to St Martin. (Eustache Le Sueur.) From the Benedictine abbey of Marmoutier.

16　St Stephen. (Ascribed to Simon Vouet [1590–1649]). From the
Benedictine abbey of Saint-Amand.

17 Statue of St Cecilia. (*c.* 1740.) From the Benedictine abbey of
Saint-Ouen, Rouen.

18 St Irene and the wounded St Sebastian. (Eustache Le Sueur.) Probably from
the Benedictine abbey of Lyre, Indre-et-Loire.

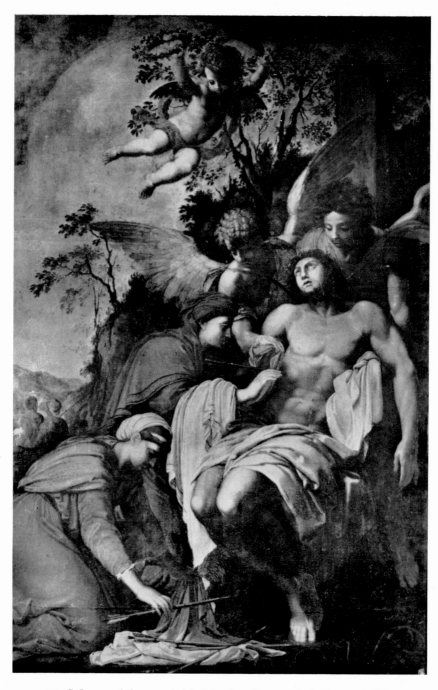

19 St Irene and the wounded St Sebastian. (Georges de la Tour, *c.* 1640.)
Probably from the Benedictine abbey of Lyre.

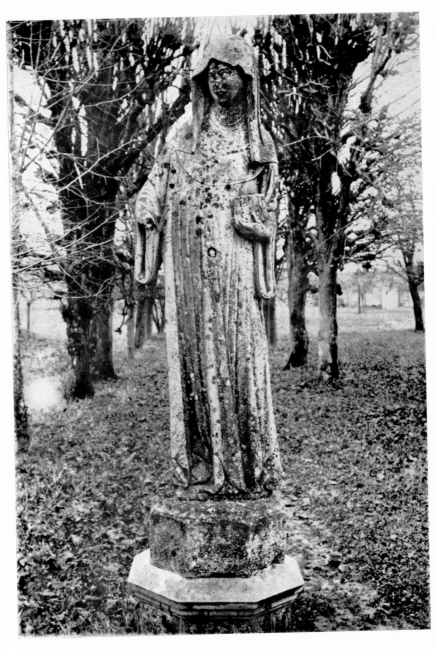

20 Statue of St Scholastica. (Late sixteenth century.) From the Benedictine
nunnery of Jouarre.

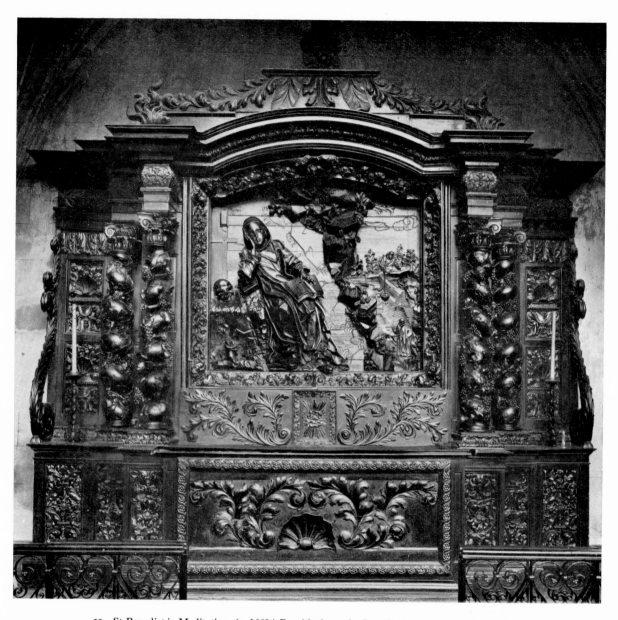

21 St Benedict in Meditation. (*c*. 1660.) Retable from the Benedictine abbey of Marmande.

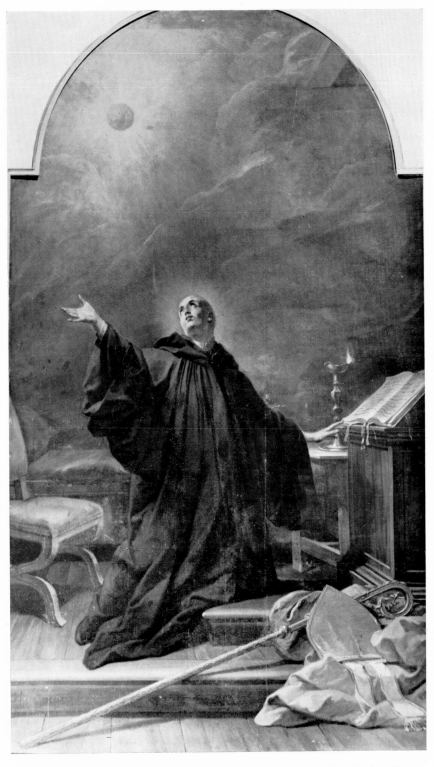

22 The ecstasy of St Benedict. (Jean Restout II, 1730.) From the Benedictine abbey
of Bourgeuil.

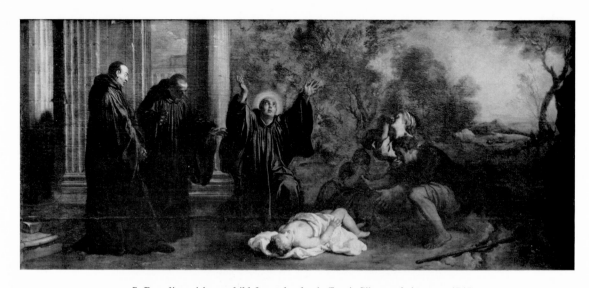

23 St Benedict raising a child from the dead. (Louis Silvestre le jeune, *c.* 1745.) From the Benedictine abbey of Saint-Martin-des-Champs, Paris.

24 Benedictine abbey of Locronan, Finisterre. Pulpit, with medallions of St Benedict's life, 1707.

25 The death of St Scholastica. (Jean Restout II, 1730.) From the Benedictine
abbey of Bourgeuil.

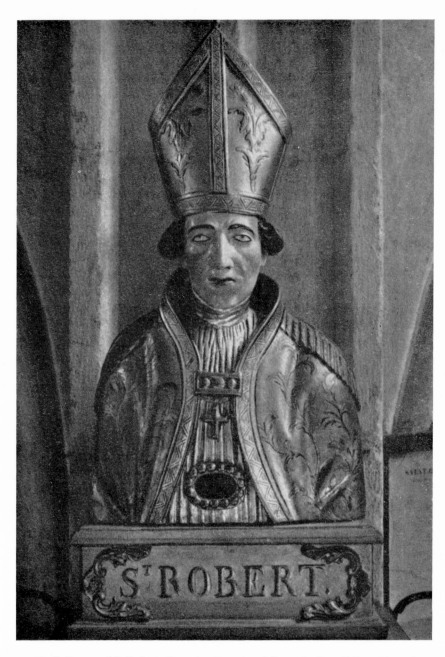

26 Reliquary of St Robert. (Seventeenth century.) From the Benedictine abbey of
La Chaise-Dieu, Haute-Loire.

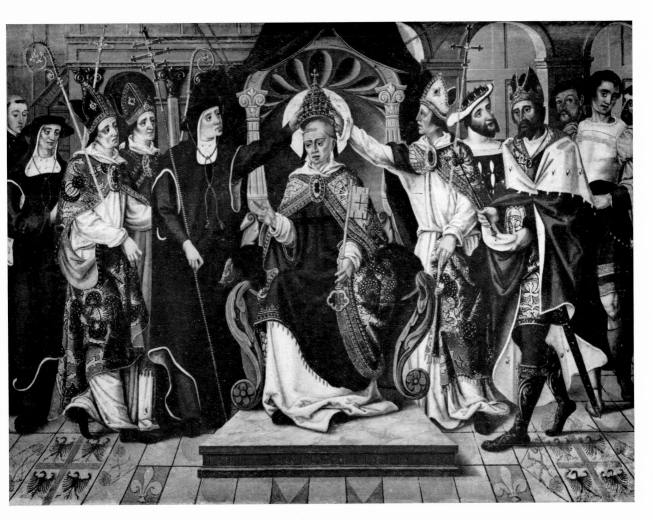

27 Coronation of Pope Célestine. (Painted between 1525 and 1542.)
From the convent of Célestins at Marcoussis.

28 Reliefs of Richard I and II, Dukes of Normandy. (Girolamo Viscardi, 1507.) On the high altar of the Benedictine abbey of La Trinité, Fécamp.

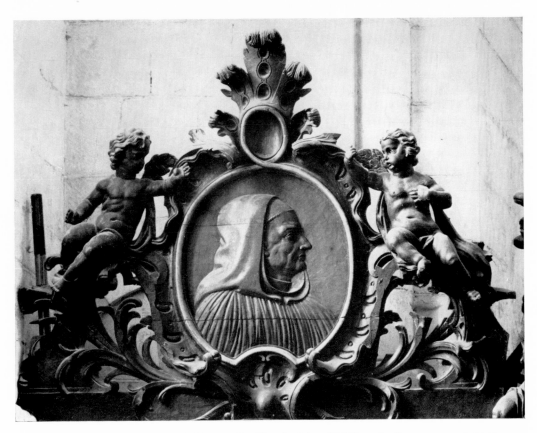

29 Medallions of (*a*) Raoul de Tancarville, Chamberlain of William the Conqueror, and (*b*) St Benedict. (1750.) From the confessionals of the Benedictine abbey of Saint-Georges-de-Boscherville.

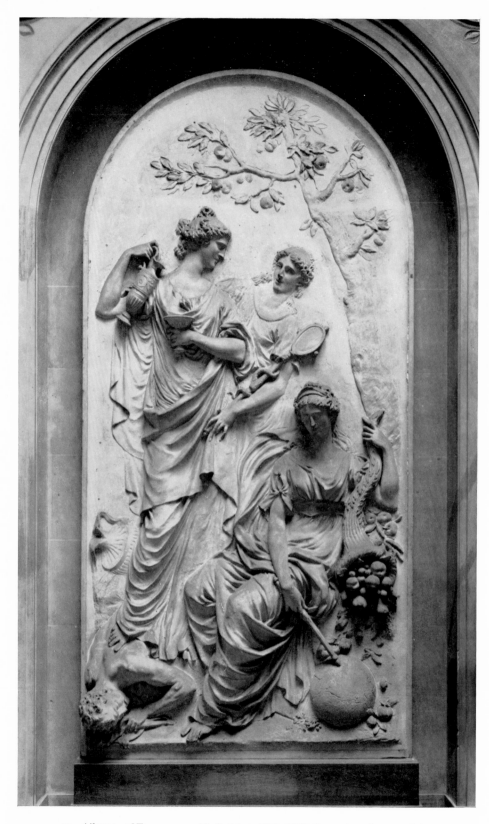

30 Allegory of Temperance. (G. Boichot, 1735–1813) From the refectory of the
Benedictine abbey of Saint-Bénigne, Dijon.

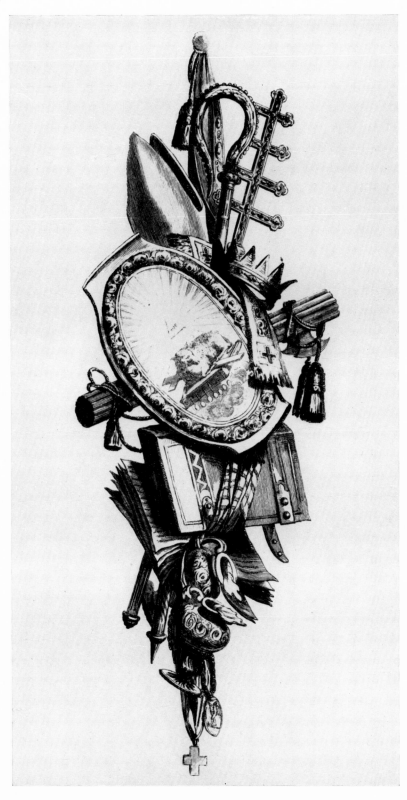

31 Trophy of monastic attributes. (Delafosse, *c.* 1770.)

32 Cistercian abbey of Boulbonne. Plaster work in the refectory. (Mid eighteenth century.)

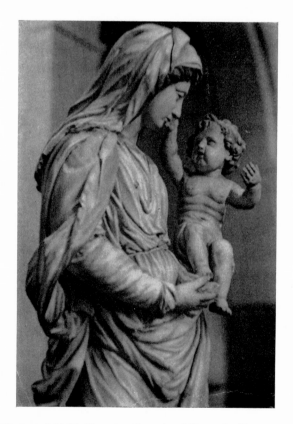

33 Statue of the Virgin and Child. (Seventeenth century.) From the Cistercian abbey of Melleray.

34 Cistercian nunnery of La Bénisson-Dieu, Loire. Retable of the Lady Chapel. (*c.* 1637.)

35 Cistercian abbey of Bonport. Retable of the rosary. (*c.* 1630.)

36 Cistercian abbey of La Clarté-Dieu. Retable of St Dominic and St Catherine
receiving the rosary. (*c.* 1680.)

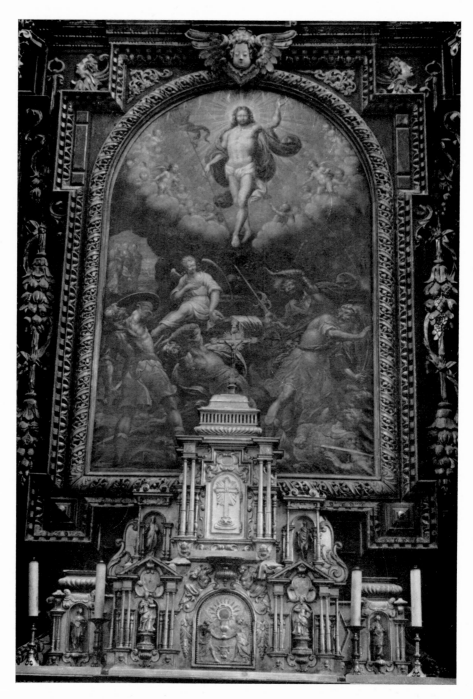

37 Cistercian abbey of Bonport. Retable of the Ascension. (*c*. 1640.)

38 Ecce Homo. (Philippe de Champaigne, *c.* 1655.) From the Cistercian
nunnery of Port-Royal.

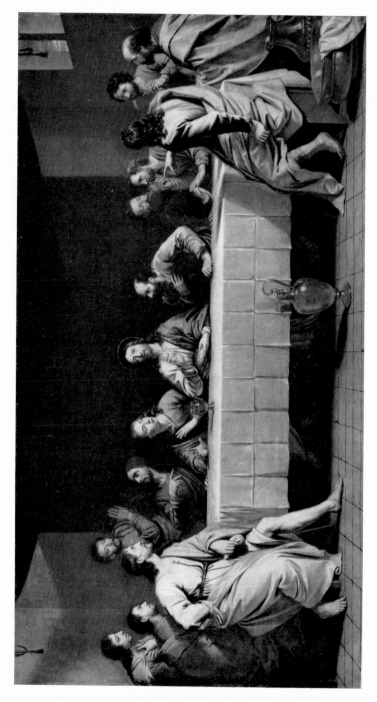

39 The Last Supper. (Philippe de Champaigne, c. 1655.) From the Cistercian
nunnery of Port-Royal.

40 Cistercian abbey of La Clarté-Dieu. Retable with St Benedict and St Bernard. (*c.* 1680.)

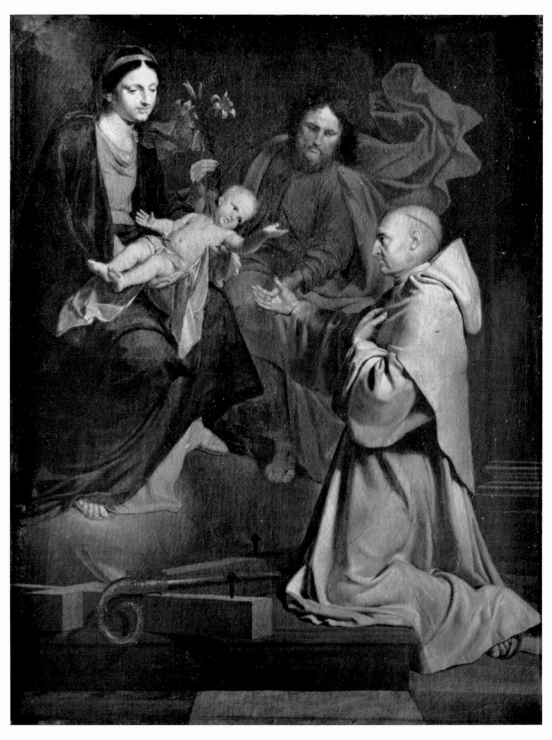

41 The vision of St Bernard. (Le Tellier [1614–76].) From a Cistercian house.

42 St Bernard offering the Host to William of Aquitaine. (Jean Restout.)
From the Cistercian abbey of Val-Dieu.

43 Portrait of a Cistercian abbot, perhaps of the Prior General of the Feuillants.
(François de Troy, 1704.)

44 Mère Agnès. (Philippe de Champaigne, 1662.) From the Cistercian nunnery of Port-Royal.

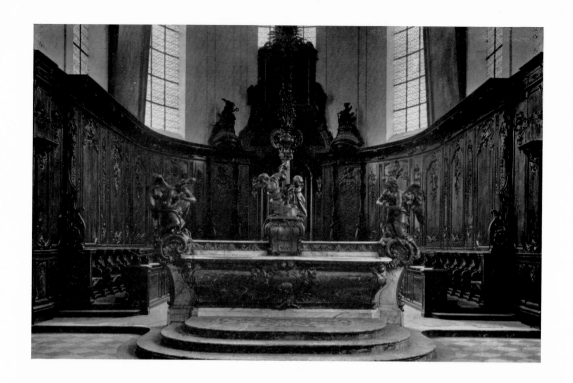

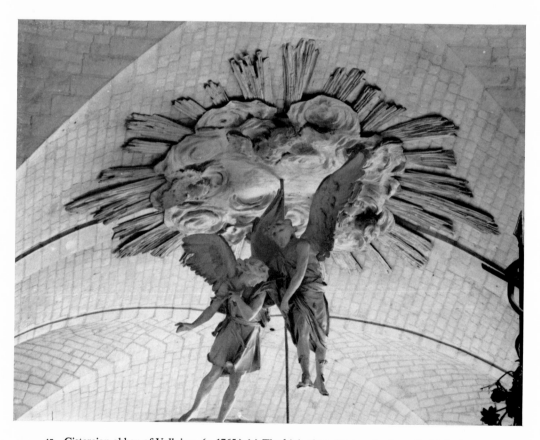

45 Cistercian abbey of Valloires. (*c*. 1765.) (*a*) The high altar. (*b*) Angels above the high altar.

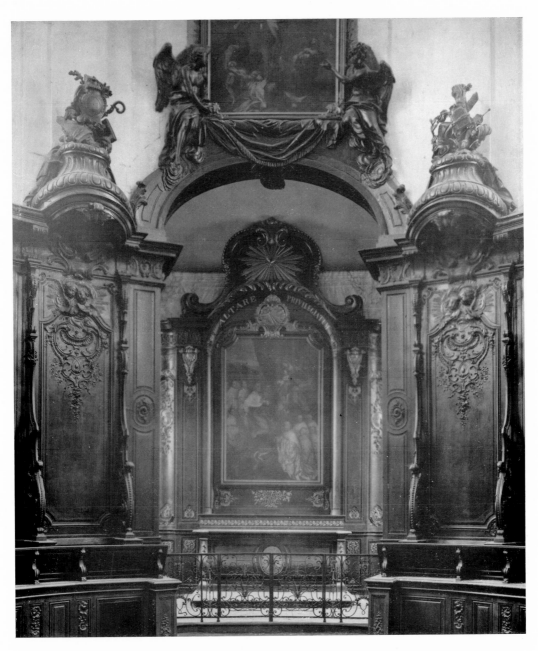

46 Cistercian abbey of Valloires. Retable of the apse, *c.* 1765.

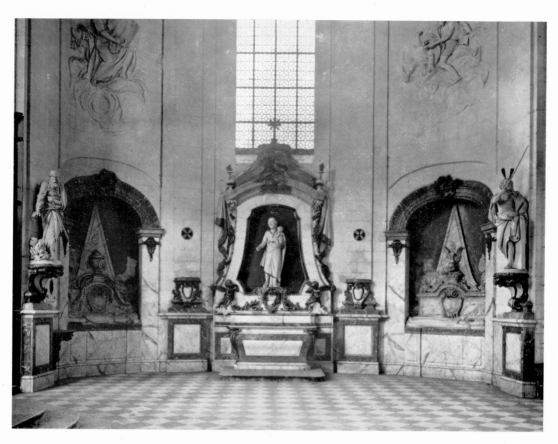

47 Cistercian abbey of Valloires. Side chapel, *c.* 1765.

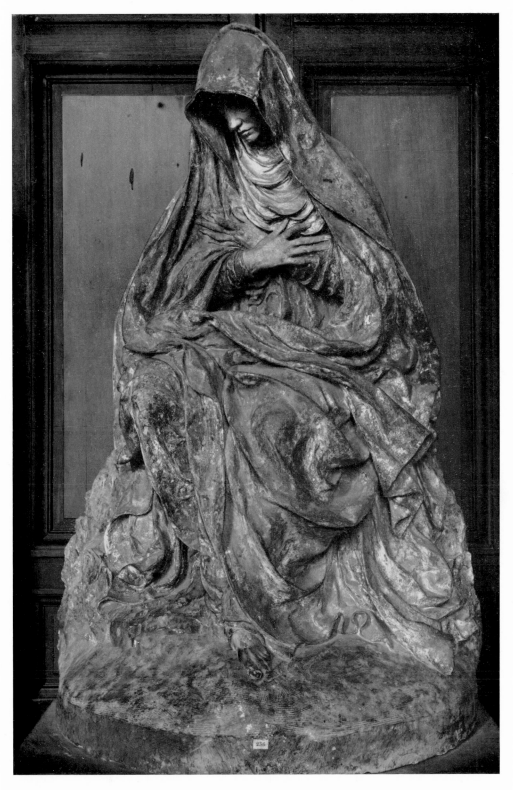

48 Our Lady of Sorrows. (Germain Pilon, *c.* 1600.) From the Augustinian abbey of
Sainte-Geneviève, Paris.

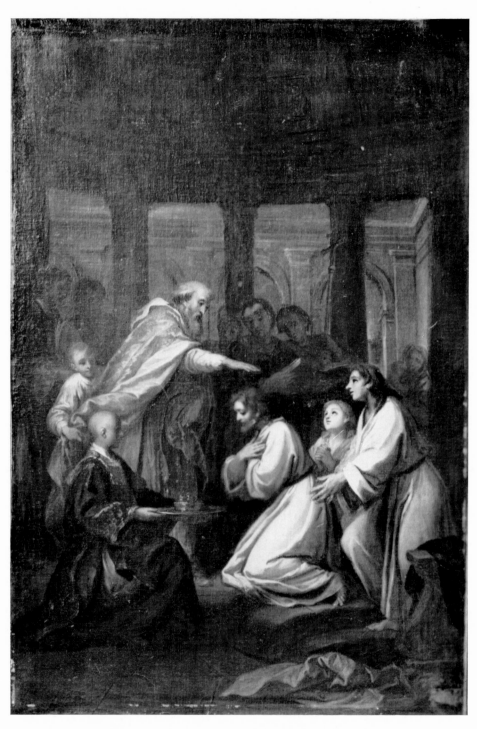

49 Baptism of St Augustine. (Louis de Boullogne [1654–1733].)

50 Consecration of St Augustine. (Louis de Boullogne.)

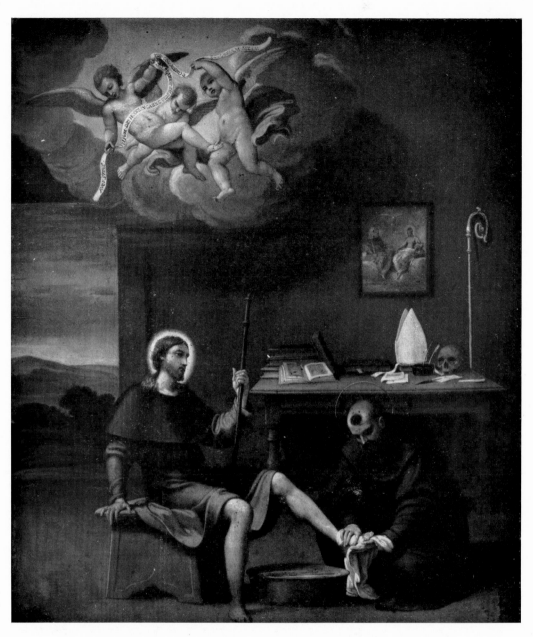

51 St Augustine washing the feet of the Pilgrim Christ. From an Augustinian house.

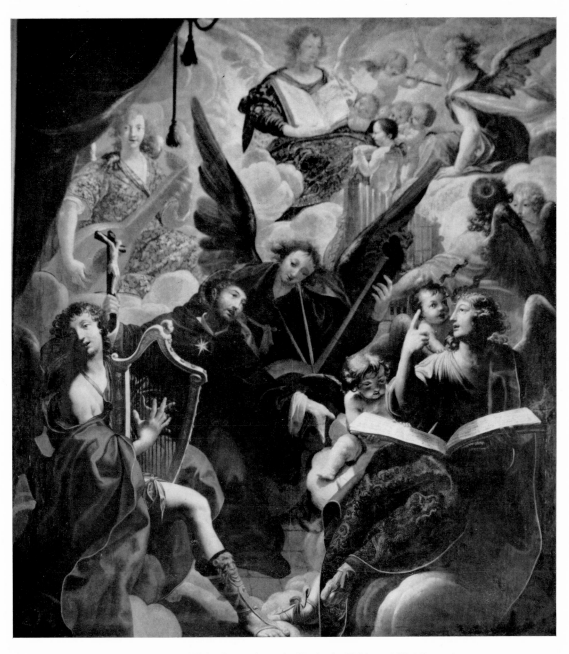

52 St Nicholas of Tolentino and angels. (Ambroise Frédeau, 1650.) From the
sacristy, Saint-Augustin, Toulouse.

53 St Nicholas of Tolentino giving alms. (Claude Guy Hallé, 1652–1736.)
From an Augustinian house.

54 Grands-Augustins, Paris. High altar (sixteenth century).

55 Louise de Pardaillan de Gondrin, last abbess of Fontevrault. (*c.* 1775.)

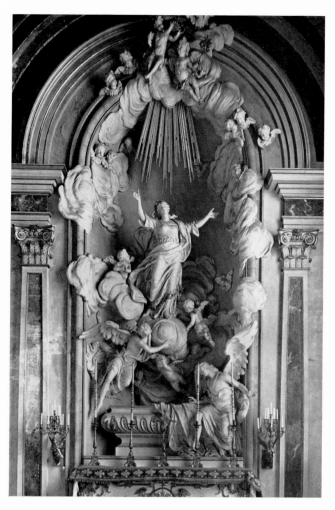

56 Premonstratensian abbey of Mondaye. Retable in chapel of the Virgin.
(Melchior Verly, *c.* 1745.)

57 Sisters of Charity presenting orphans to St Vincent de Paul. (Jaques Gamelin, 1786.)
From the house of the Sisters of Charity, Narbonne

58 Sisters of Nôtre Dame de la Charité adoring the Sacred Hearts of Jesus and Mary. (Jean
Lamy, 1735.) From the convent of the Dame des la Charité du Refuge, Tours.

59 Assumption of the Virgin. (Charles Lamy, 1734.) From the convent of the
Dames de la Charité du Refuge, Tours.

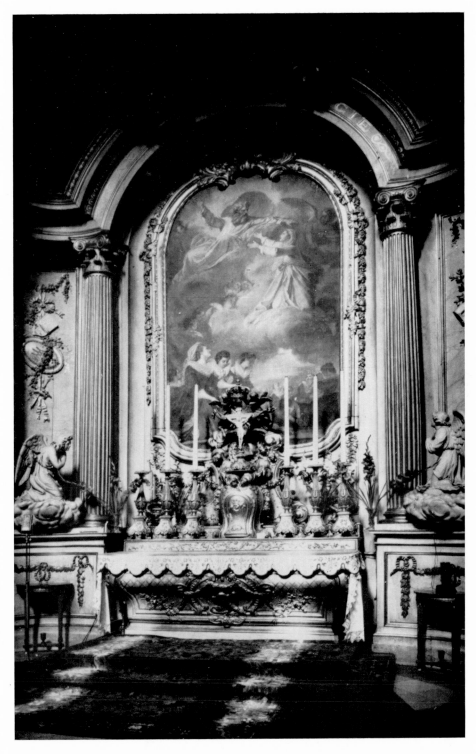

60 Chapel of the Dames de la Charité du Refuge, Besançon. High altar.

61 Ursuline convent, Auxerre. Relief over chapel door. (c. 1580.)

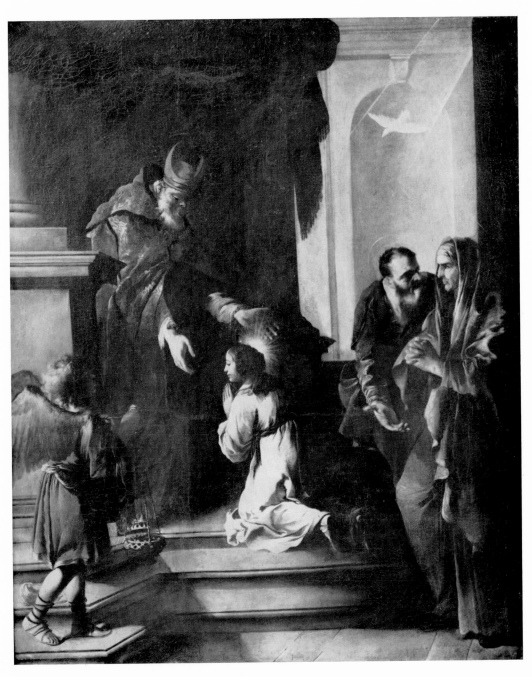

62 Presentation of the Virgin in the Temple. (Jean Tassel, 1648.)
From the Ursuline convent, Dijon.

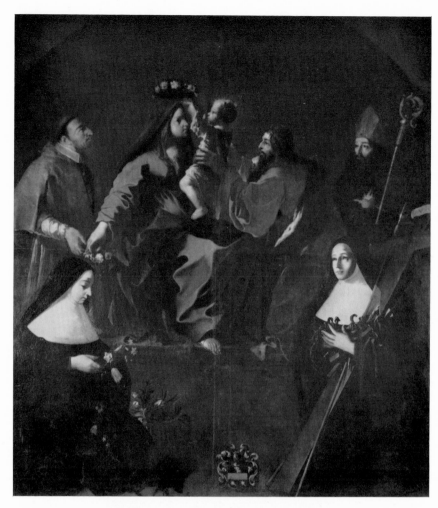

63 Coronation of the Virgin. (Jean Tassel, 1648.) From the Ursuline convent, Dijon.

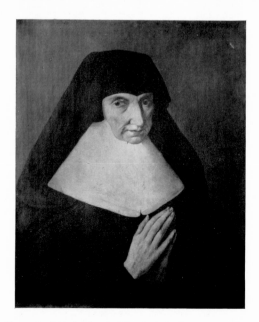

64 Portrait of Cathérine de Montholon. (Jean Tassel, c. 1650.)
From the Ursuline convent, Dijon.

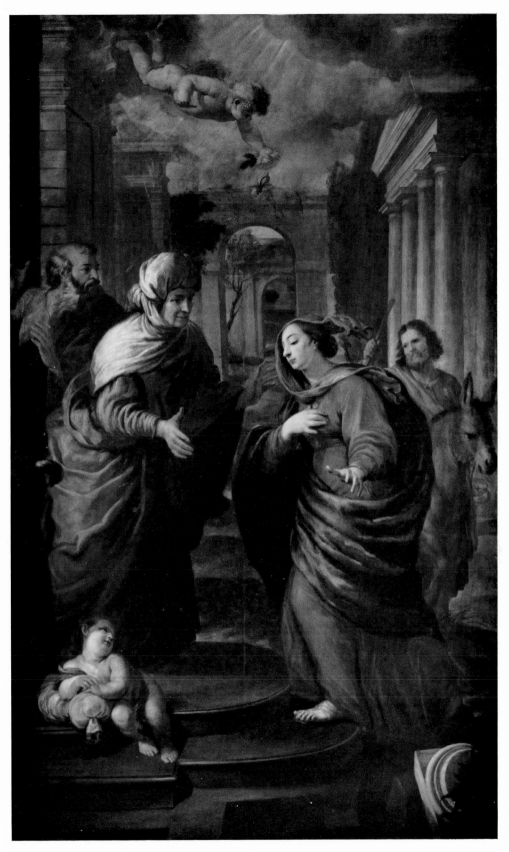

65 The Virgin visits St Elizabeth. (François Puget, 1680.) From the
Visitandine convent, Marseilles.

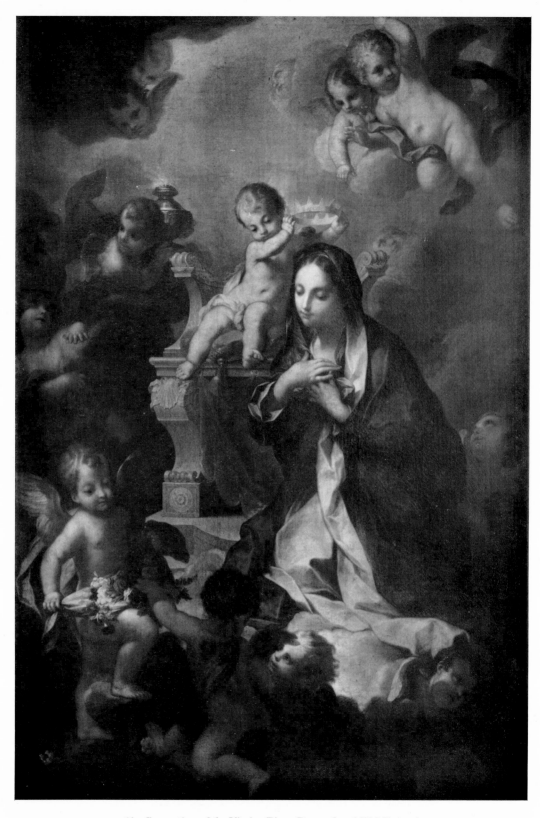

66 Coronation of the Virgin. (Pierre Parrocel, *c.* 1690.) From the
Visitandine convent, Marseilles.

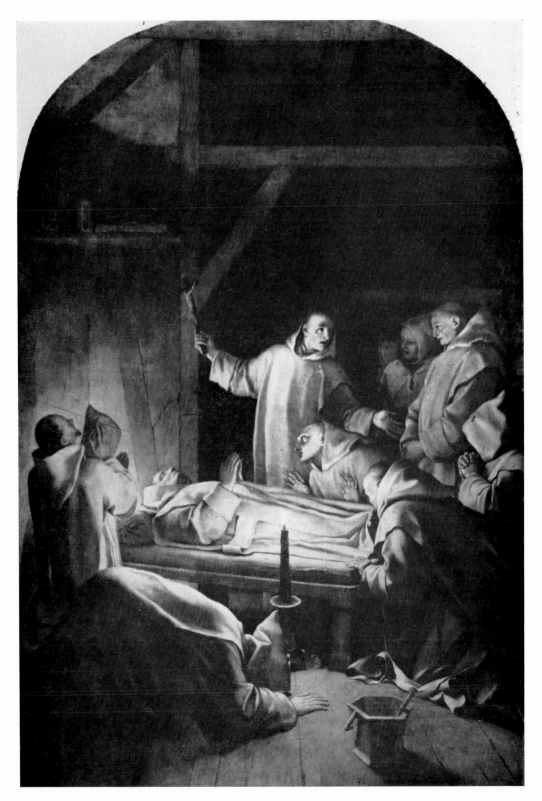

67 Death of St Bruno. (Le Sueur, 1645–8.) From the Lesser Cloister,
Charterhouse of Paris.

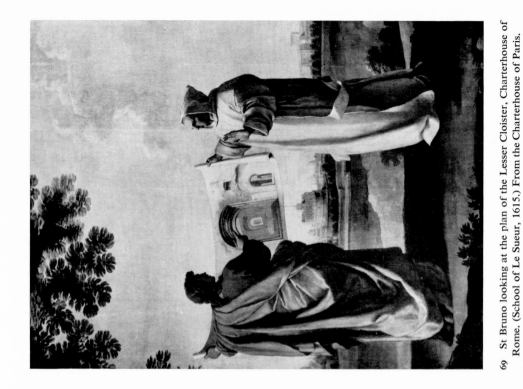

69 St Bruno looking at the plan of the Lesser Cloister, Charterhouse of Rome. (School of Le Sueur, 1615.) From the Charterhouse of Paris.

68 St Bruno in prayer. (Le Sueur, 1645–8.) From the Lesser Cloister, Charterhouse of Paris.

70 Stucco relief of Prudence. (P. Lucas, 1749.) From the choir of
St-Pierre-des-Chartreux, Toulouse.

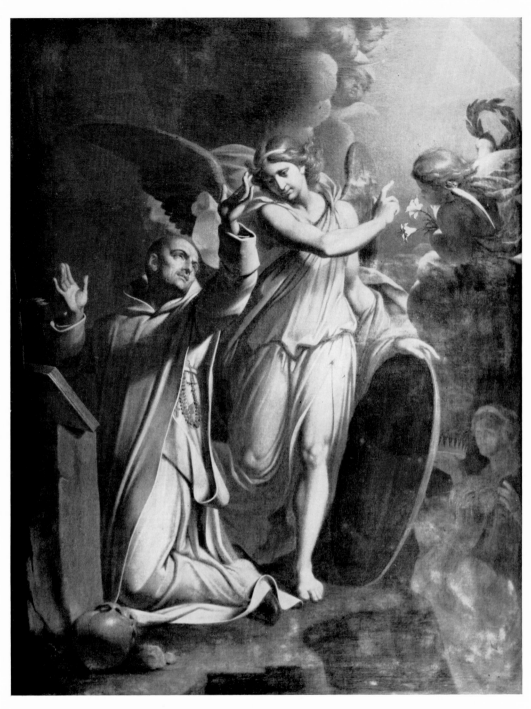

71 St Bruno in prayer. (Nicolas Sacquespée, *c.* 1675.) From the Charterhouse of Rouen.

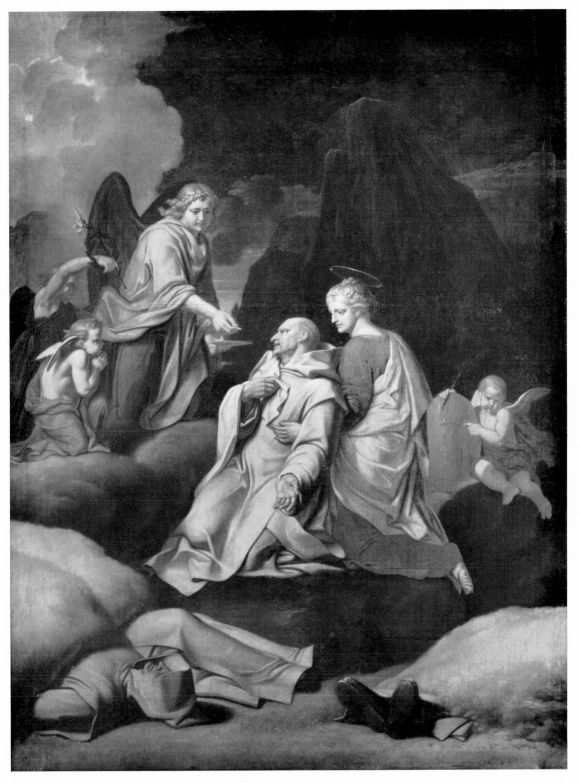

72 Carthusians in the snow. (Nicolas Sacquespée.) From the Charterhouse of Rouen.

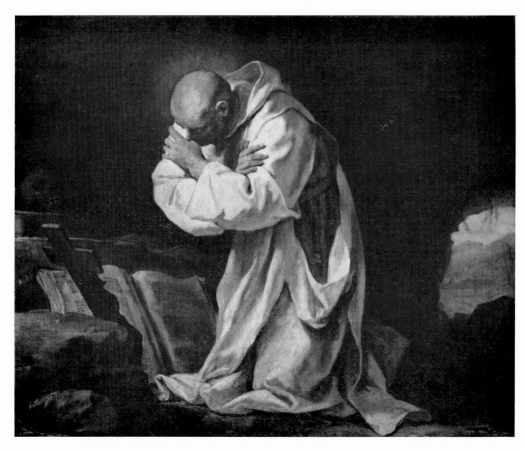

73 St Bruno in meditation in the desert. (Jean Restout II, 1763.) From the Charterhouse of Paris.

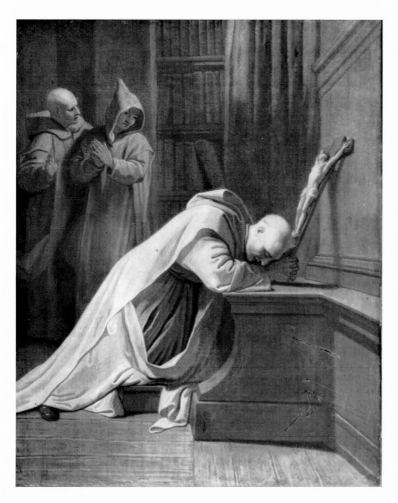

74 St Bruno adoring the Cross. (Jean Baptiste Jouvenet, *c.* 1675.) From the
Charterhouse of Lyons.

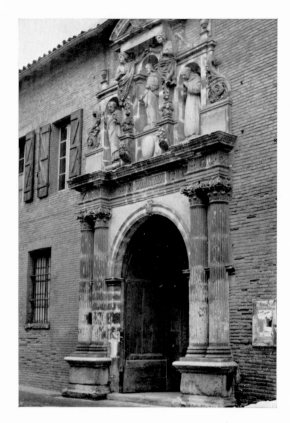

75 St Bruno, St Peter and Christ. From the gateway of St-Pierre-des-Chartreux, Toulouse.

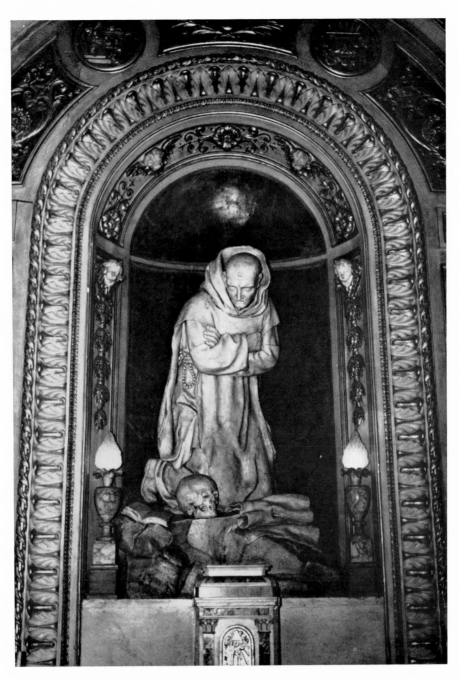

76 St Bruno in meditation. (Jacques Sarrazin, *c.* 1628.)
St-Bruno-des-Chartreux, Lyons.

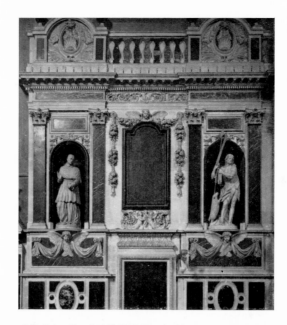

77 St Bruno and St John Baptist. (1672.) North side of the choir, St-Bruno, Bordeaux.

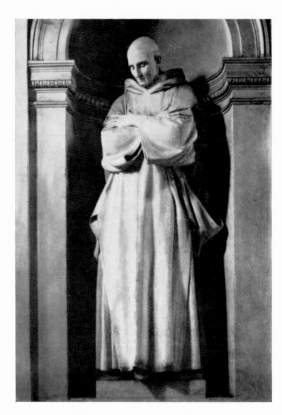

78 St Bruno. (Houdon, *c*. 1769.)

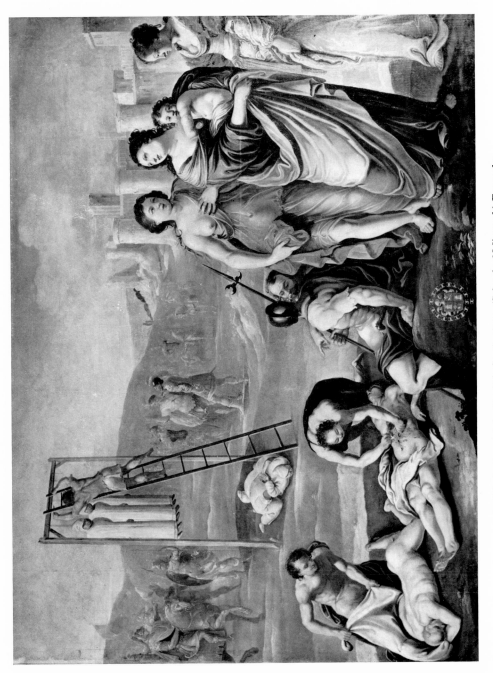

79 Martyrdom of the English Carthusians. (School of Mignard.) From the
Charterhouse of Villeneuve-lès-Avignon.

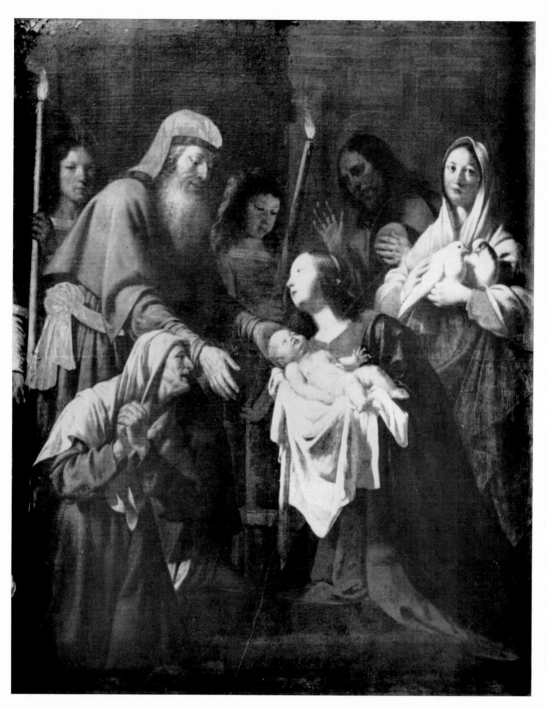

80 The Purification. (Guy François, *c.* 1645–50.) From St-Pierre-des-Chartreux, Toulouse.

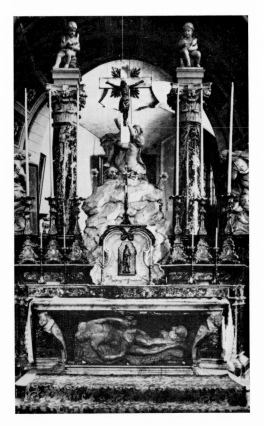

81 High altar. From the Charterhouse of Val-Bénite. (Antoine Duparc, *c.* 1740?)

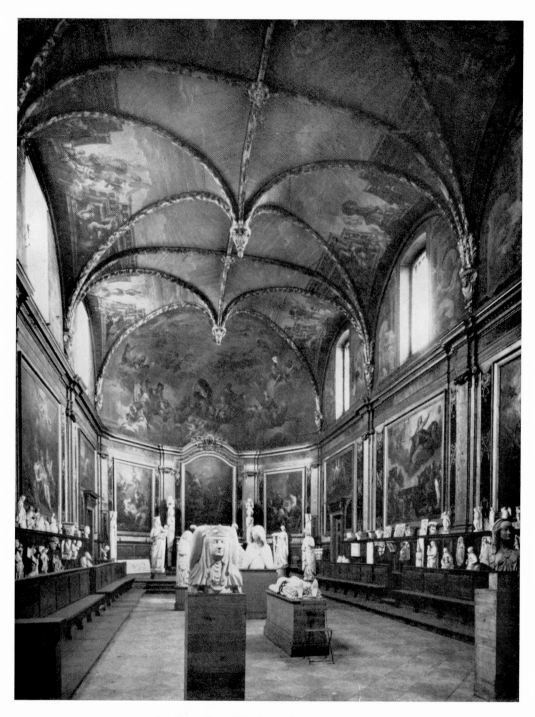

82　Carmelites of Toulouse. Chapel, begun 1622.

83 Elisha and the Prophets. (J. B. Despax [1709–73].) Carmelite chapel, Toulouse.

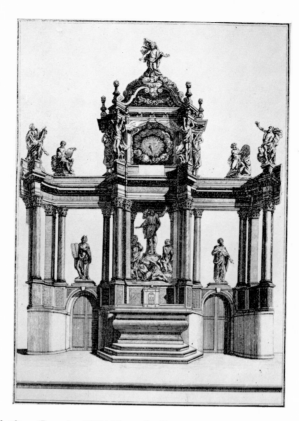

84 High altar. (Jacquin, 1683.) From the Carmelites of the Place Maubert, Paris.

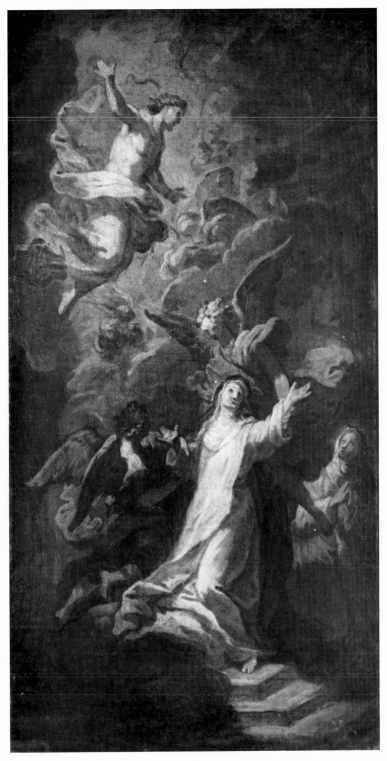

85 The vision of St Teresa. (Jean Jouvenet, *c.* 1700.)

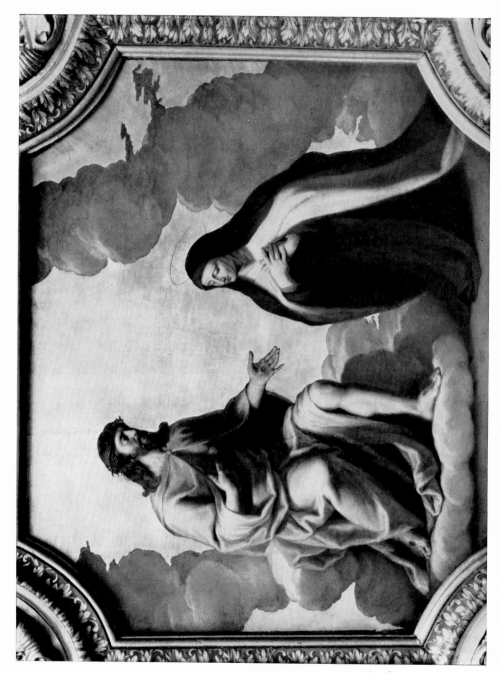

86 Christ showing St Teresa his wounds. (Philippe de Champaigne, 1631–81.) From the Carmelites of Aix-en-Provence.

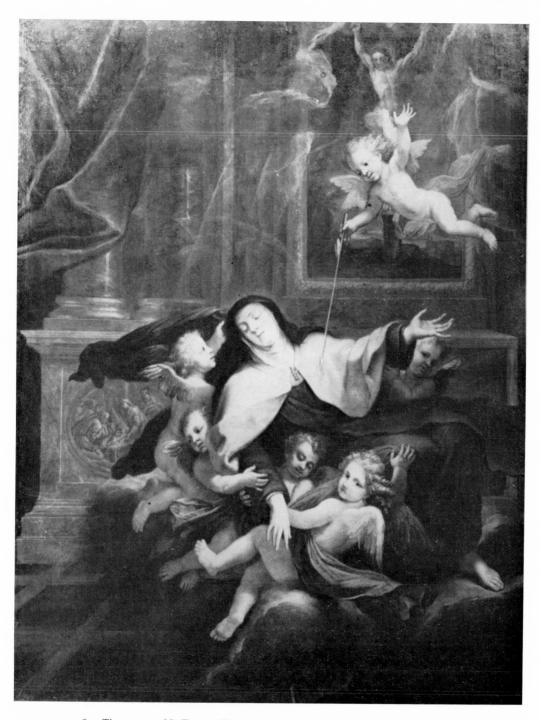

87 The ecstasy of St Teresa. (French school, *c.* 1726.) From the Paris Carmelites.

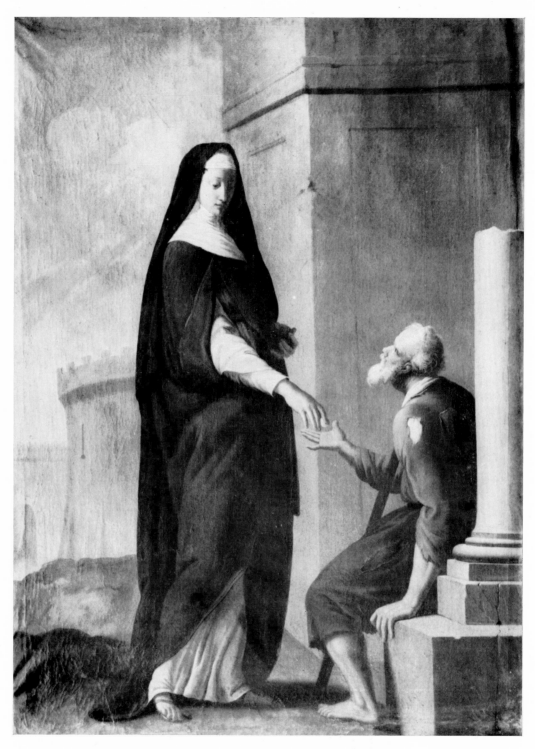

88 A Carmelite nun giving alms. (? Sébastien Bourdon.)

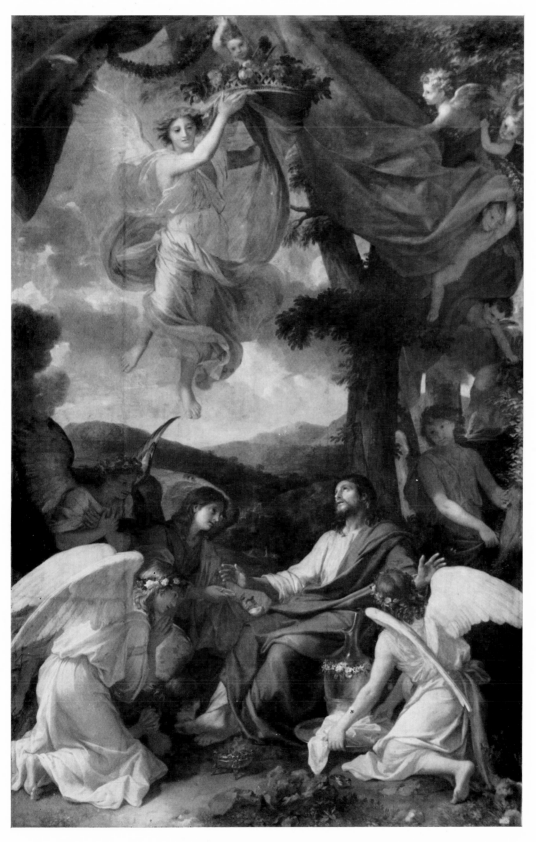

89 Christ in the wilderness. (Charles Le Brun, [1619–90].) From the Carmelites of Paris.

90 (a) St Peter. (b) St Paul. (Artus Quellin of Antwerp, c. 1702.)
From the Carmelites of Lille.

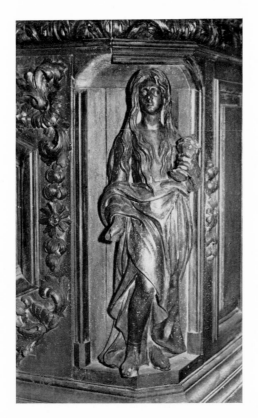

91 St Mary Magdalene. (Vincent Funel, 1692.) From the Dominican convent of
Saint-Maximin.

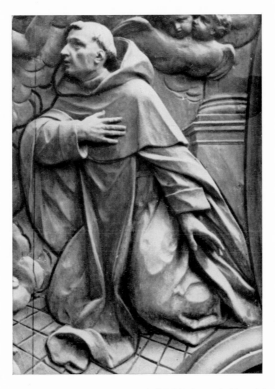

92 Medallion of St Dominic. (Vincent Funel, 1692.) From the Dominican convent of
Saint-Maximin.

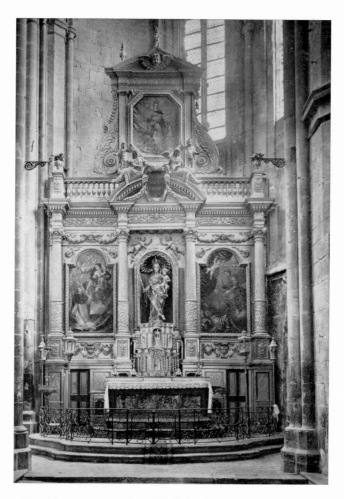

93 Dominican convent of Saint-Maximin. Altar of the Rosary. (*c.* 1670.)

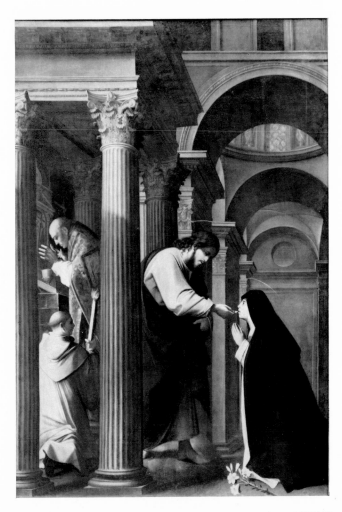

94 The Mystic Communion of St Catherine. (Philippe Quantin, *c.* 1635.) From the
Jacobines of Dijon.

95　St Rose of Lima. From the Dominicans of Nantes.

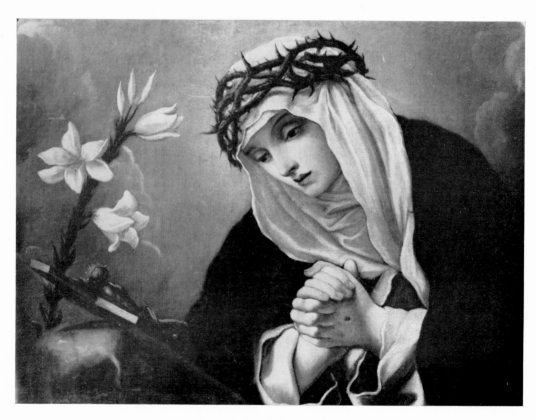

96　St Catherine of Sienna in meditation. (Frère Jean André [1666–1753].) From the
Dominicans of Nantes.

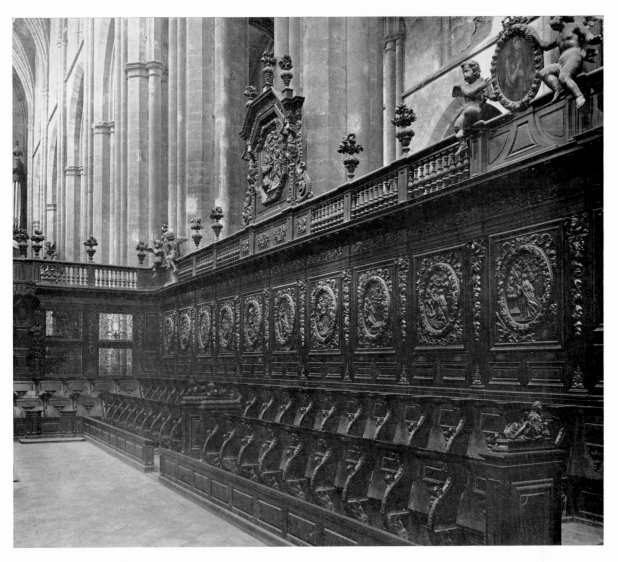

97 Dominican convent of Saint-Maximin. Stalls (1692).

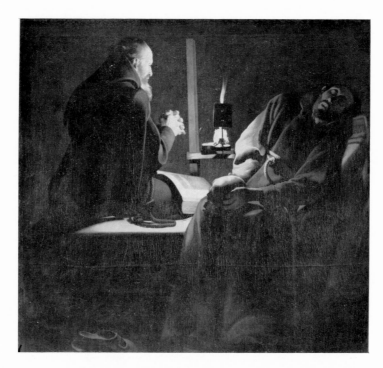

98 Ecstasy of St Francis. (Georges de la Tour, *c*. 1630.) Probably painted for a
Franciscan house.

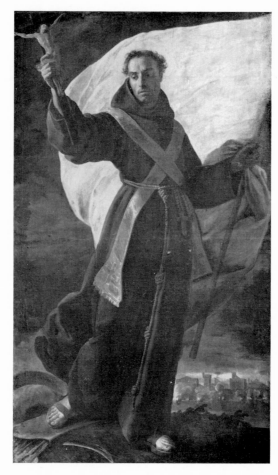

99 St John Capistrano. (Antoine Rivalz, *c*. 1710.) From the
Franciscan convent of Toulouse.

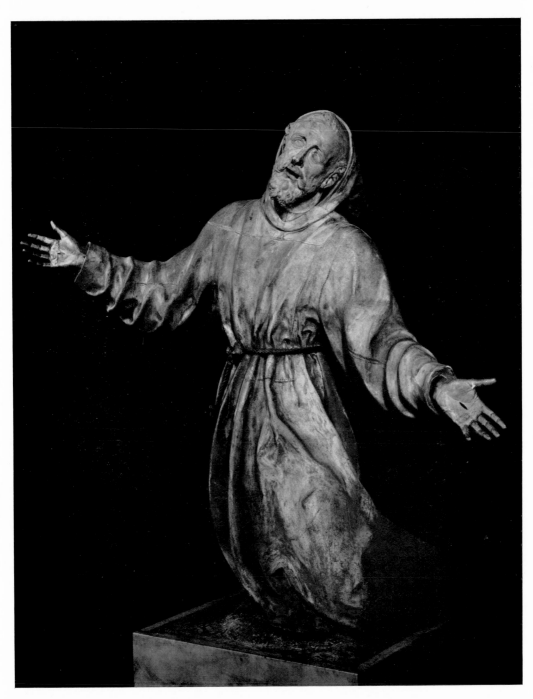

100 St Francis in Ecstasy. (Germain Pilon, *c.* 1540.) From the Capuchins of Paris.

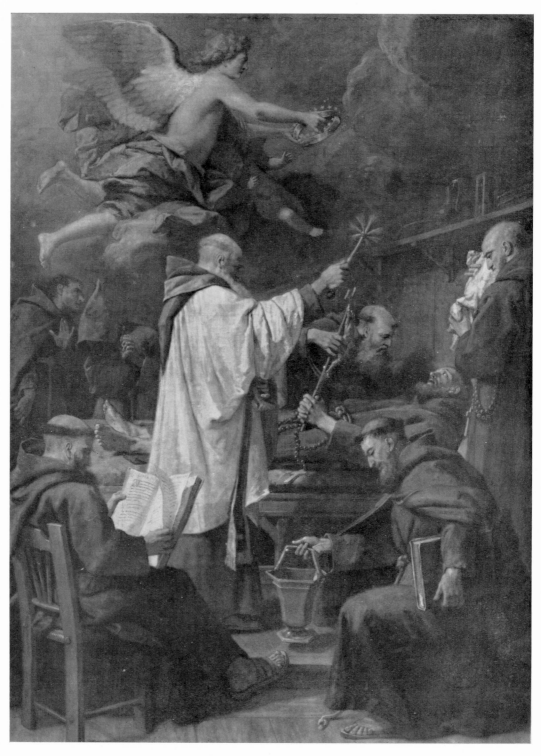

101 Death of St Francis. (Jean Jouvenet, 1713–14.) From the Capuchins of Paris.

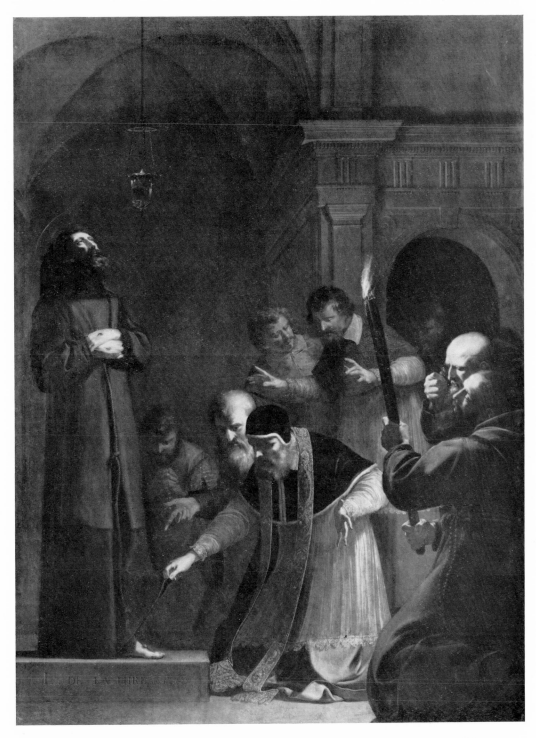

102 Pope Nicholas V having the tomb of St Francis opened. (Laurent de la Hyre, 1630.)
From the Capuchins of Paris.

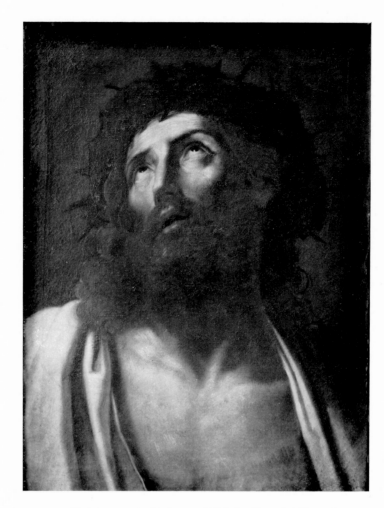

103　Christ crowned with thorns. (Nicholas Quantin.) From the
Capuchins of Dijon.

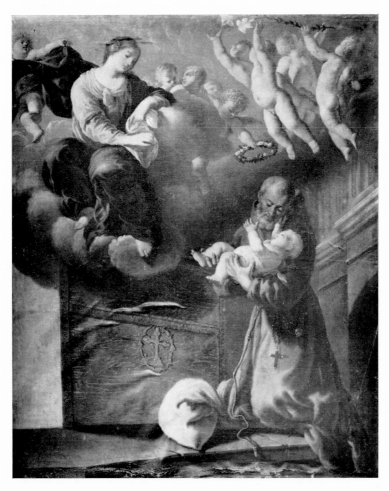

104 St Felix de Cantalice. (Verrio, 1639–1707.) From the
Capuchins of Toulouse.

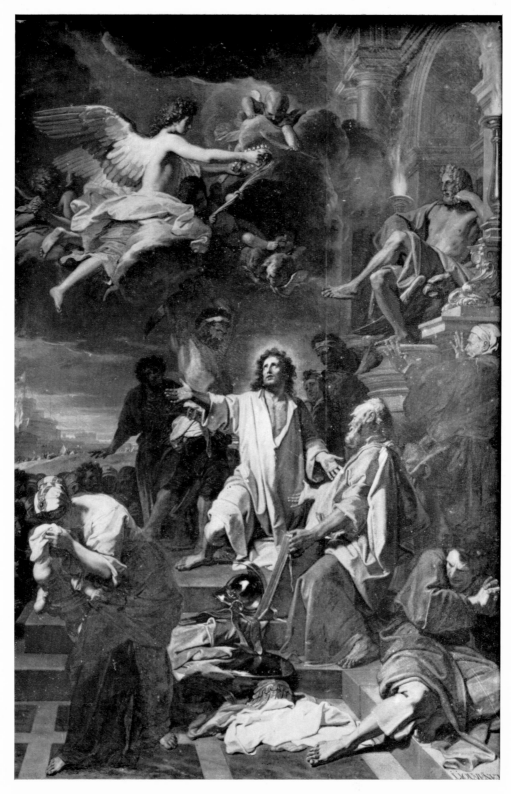

105 Martyrdom of St Ovide. (Jean Jouvenet, 1690.) From the Capuchines,
Place Vendôme, Paris.

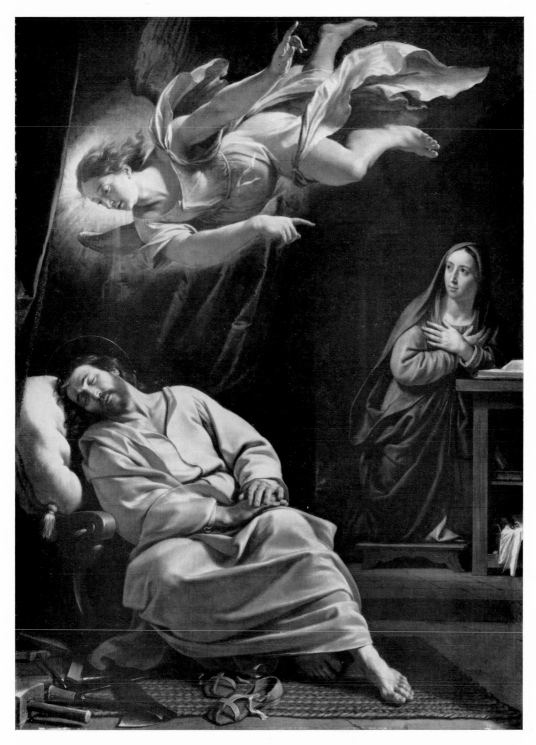

106 Dream of St Joseph. (Philippe de Champaigne, c. 1665.)
From the Minimes of Paris. (The National Gallery.)

107 (*a*) and (*b*) Jesuit college, Rouen. The Chapel, 1615–56.

108 Jesuit college, Chaumont. The Chapel, 1629.

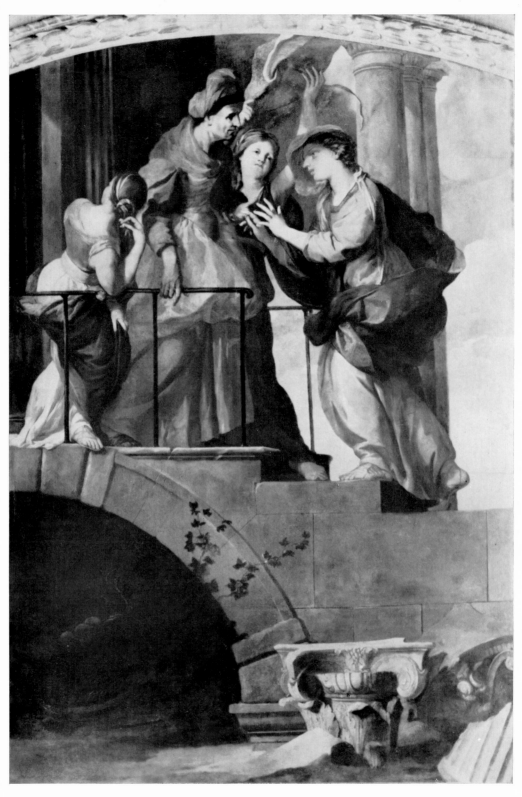

109 The Visitation. (Pierre Puget, 1658–60.) From the Chapel of the
Jesuit college, Aix-en-Provence.

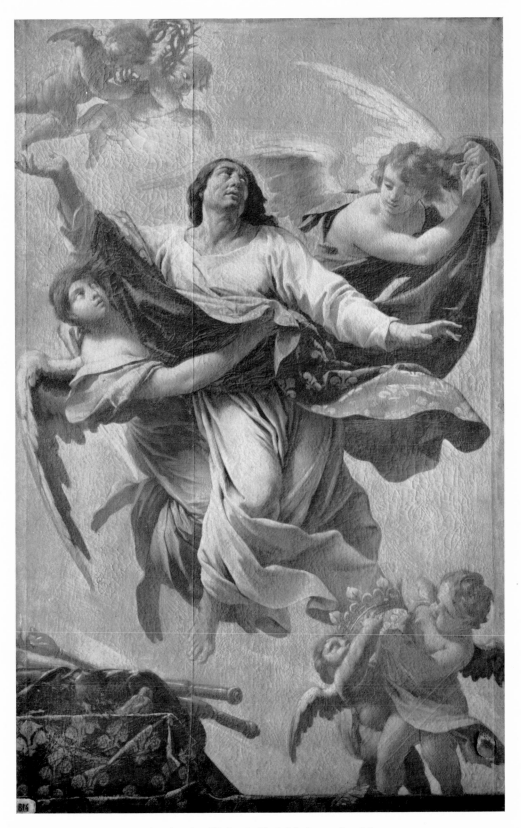

110 Apotheosis of St Louis. Probably from a Jesuit house.

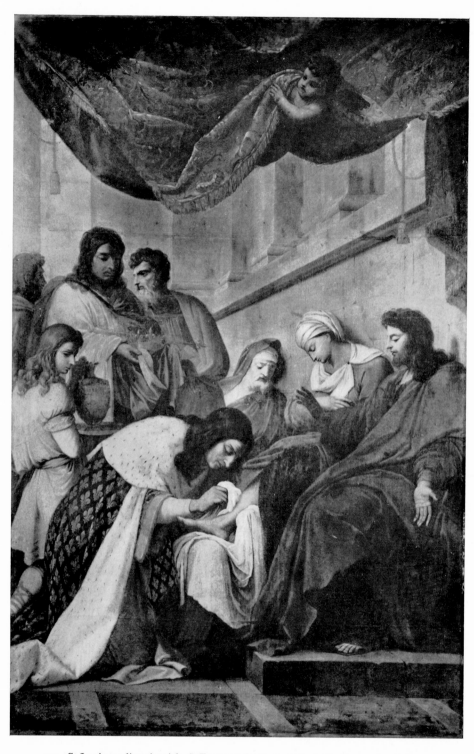

III St Louis tending the sick. (? Eustache Le Sueur.) Probably from a Jesuit house.

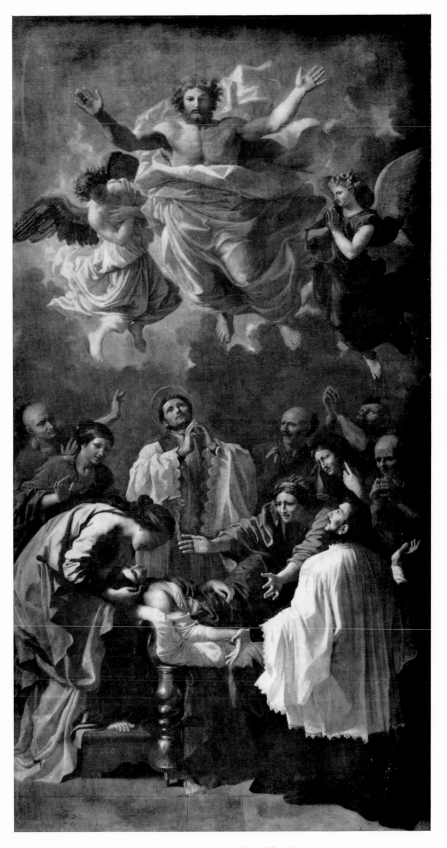

112 St Francis Xavier brings a Japanese girl to life. (Nicolas Poussin, *c.* 1641.)
From the Jesuit Novitiate, Paris.

113 Apotheosis of St Francis Xavier. (Guillaume Coustou, 1744.) From the
Jesuit church of Saint-Paul, Bordeaux.

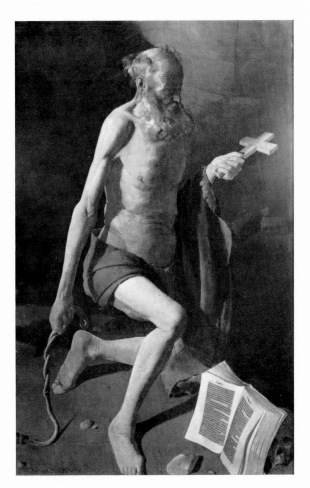

114 St Jerome. (Georges de la Tour, *c.* 1630.) From
Saint-Antoine-en-Viennois.

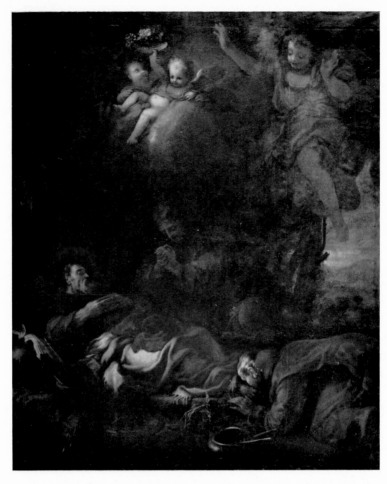

115 Death of St Anthony. (? P. Parrocel.) From the abbey of
Saint-Antoine-en-Viennois.

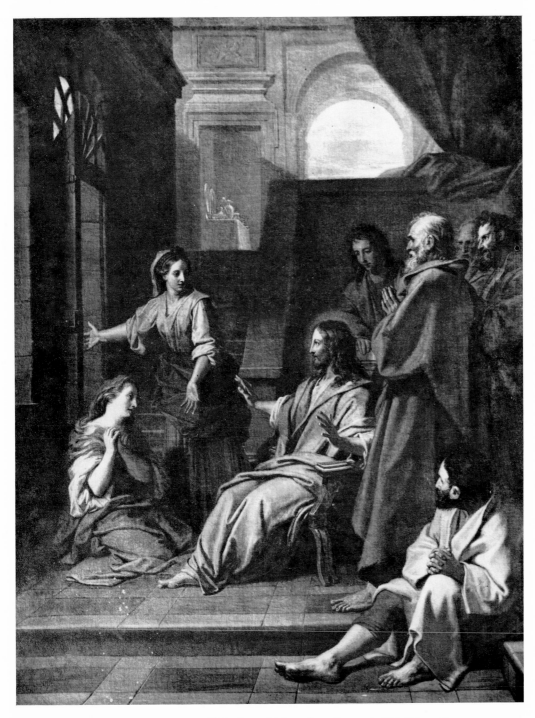

116 Christ in the house of Martha and Mary. (Jean Jouvenet, 1706.) From the
Pères de Nazareth, rue du Temple, Paris.

BIBLIOGRAPHY

When not otherwise stated, books are published in Paris

ANON. *Catalogue des tableaux exposés au Musée de Troyes.* 1886.

ANON. *Ville d'Amiens. Catalogue des tableaux et sculptures du Musée de Picardie.* Amiens, 1911.

AUZAS, P. M. 'La Visitation de Pierre Menard', *Bull. de la Soc. de l'hist. de l'art français* (1959), p. 23.

—— 'Précisions sur Michel Corneille et ses fils', *Bull. de la Soc. de l'hist. de l'art français* (1962), p. 45.

BEAULIEU, M. MICHEL. 'Anguier et le maître autel au Val de Grace', *Bull. de la Soc. de l'hist. de l'art français* (1945), p. 6.

BELIN, A. *Les Emblèmes eucharistiques.* 1647. (By an error the title-page gives 1547.)

BLUNT, A. *Art and Architecture in France, 1500–1700.* London, 1953.

BRÉMOND, H. *Histoire littéraire du sentiment religieux en France.*

BRIÈRE, G. 'La "Vierge de Douleur" de Germain Pilon', *Bull. de la Soc. de l'hist. de l'art français* (1912), p. 352.

—— *Musée du Louvre, Catalogue des peintures exposées dans les galeries.* I. *Ecole française.* 1924.

CHARVET, E. L. G. 'Recherches sur . . . Thomas Blanchet, peintre et architecte', *Revue du Lyonnais,* XIX (Lyons, 1895), 57, 156, 269, 357 and 431.

CHENNEVIÈRES-POINTEL, CHARLES PHILIPPE, DE. *Peintres provinciaux de l'ancienne France.* n.d.

—— AND MONTAIGLON, A. DE. *Abécédario de P. J. Mariette, et autres notes inédites sur les arts et les artistes.* 6 vols. 1851–60.

—— AND MONTAIGLON, A. DE. *Recherches sur la vie et les œuvrages de quelques peintres provinciaux de l'ancienne France.* 4 vols. 1847–62.

CLOUZOT, H. 'Une famille de peintres Poitevins', in *Archives de l'art français,* nouvelle série, VIII (1916), 46.

Congrès Archéologique: see Société française d'archéologie.

COURAJOD, L. *Alexandre Lenoir, son journal, et le Musée des Monuments Français.* 2 vols, 1878, 1886.

CROZET, R. *L'Abbaye de Noirlac et l'architecture cistercienne en Berry.* 1932.

DEJOB, C. *De l'influence du Concile de Trente sur la littérature et les Beaux Arts chez les peuples catholiques.* 1884.

DEMOINGNE, P. *Jean Monbaer de Bruxelles, Abbé de Livry, ses écrits et ses réformes.* Louvain and Toulouse, 1927.

DEREL, J. P. 'Le maître autel de Saint-Martin-des-Champs', *Bull. de la Soc. de l'hist. de l'art français* (1957), p. 159.

DESCAMPS, J. BAPTISTE. *La vie des peintres flamands, allemands et hollandois.* 4 vols. 1753–63.

DEZALLIER d'ARGENVILLE, A. J. *Abrégé de la vie des plus fameux peintres.* 1745.

DIDEROT, *Salons,* ed. Seznec and Adhémar. Oxford, 1963.

DIGARD, M. *Jacques Sarrazin. Son œuvre, son influence.* 1934.

BIBLIOGRAPHY

DORIA, A. 'Les peintures religieuses de Pierre van Mol aux Carmes', *Revue de l'art ancien et moderne*, LXVII (1935), 77.

FYOT. *Jean Dubois*. n.d.

GAZIER, AUGUSTIN. *Philippe et Jean Baptiste de Champaigne*. 1893.

GUIFFREY, J. 'Inventaire des peintures et sculptures du Couvent des Cordeliers à Paris . . . en 1790', *Bull. de la Soc. de l'hist. de l'art français*, nouvelles archives, 2nd ser. II (1880–1), 265.

GUILLET DE SAINT GEORGES, G. *Mémoires inédits sur la vie et les ouvrages des membres de l'Académie Royale de peinture et de sculpture*. 2 vols. 1854.

HÉLYOT, P. 'Dictionnaire des ordres religieux'. 4 vols. ed. M. L. Badiche, in Migne, *Encyclopédie théologique*, 1847–59, in which it is vols. XX–XXIII.

JOUIN, H. *Charles le Brun*. 1889.

LAUGIER, P. *Manière de bien juger les ouvrages de peinture*. 1771.

LEMONNIER, H. *L'art français au temps de Louis XIV, 1661–1690*. 1911.

—— *L'art français au temps de Richelieu et de Mazarin*. 1893.

LORIQUET, C. *Catalogue . . . du Musée de Rheims*. Rheims, 1881.

LOSSKY, B. 'Identifications récentes parmi les peintures français du Musée de Tours', *Bull. de la Soc. de l'hist. de l'art français* (1957), p. 103.

—— B. 'Deux tableaux de l'Adoration du Sacré-Cœur au Musée de Tours', *Bull. de la Soc. de l'hist. de l'art français* (1959), p. 109.

—— 'Charles Lamy, peintre de l'Académie Royale, 1688–1743', *Archives de l'art français*, new series, XXII (1959), 108.

—— *Catalogue des tableaux du XVIIIe du Musée de Tours*. 1962.

MÂLE, EMILE. *L'Art religieux après le Concile de Trente*. 1932.

—— *L'Art religieux du XIIe siècle en France*. 1922.

MARCEL, G. *Catalogue des Tableaux . . . du Musée de Caen*. Caen, 1899.

MARIETTE, J. *L'Architecture française*. Reprint of 1727 ed., ed. L. Hautecour. 3 vols., Paris and Brussels, 1927.

MARQUET DE VASSELOT, J. J. 'Répertoire des Catalogues des Musées de Province', *Bull. de la Soc. de l'hist. de l'art français* (1923).

MÉRY, ABBÉ. *La théologie des peintres, sculpteurs graveurs et dessinateurs*. 1765.

MILLIN, A. L. *Antiquités Nationales. Bibl. Nat. III (Drouhin)*.

MOLANUS, J. *De picturis et imaginibus sacris*. Louvain, 1570.

MONGET, C. *La Chartreuse de Dijon*. Montreuil-sur-Mer. 3 vols. 1898.

NÈVE, E. *Des travaux de Jean Molanus sur l'iconographie chrétienne*. Louvain, 1847.

PICHARD. *Peintures du Musée d'Alençon*. 8 vols. 1938.

PIGANIOL DE LA FORCE. *Description historique de la Ville de Paris et ses environs*. 10 vols. new ed. 1765.

POINTEL, *see* Chennevieres-Pointel.

PONTIER, H. *Musée d'Aix, Bouches-du-Rhône. Les peintures*. Aix, 1900.

POSSEVAN, A. *Tractatio de Poesi et Pictura ethnica, humana et fabulosa, collata cum vera, honesta et sacra*. Lyons, 1594.

RÉAU, L. *Iconographie de l'art chrétien*. 5 vols. 1955–9.

RICHEOME, L. *Tableaux Sacrez des figures mystiques du très-auguste sacrifice et sacrement de l'Euchariste*. 1601.

RONOT, H. 'Les dessins des peintres langrois Tassel', *Bull. de la Soc. de l'hist. de l'art français* (1956), p. 86.

ROSCHACH, E. *Catalogue des collections de peinture du Musée de Toulouse*. Toulouse, 1920.

ROUCHÈS, G. *Eustache Le Sueur*. 1923.

Sociéte française d'archéologie. *Congrès Archéologiques*. Whole series.

STEIN, H. *Etat des objets d'art placés dans les monuments religieux et civils de Paris au début de la révolution française*. 1890.

VANUXEM, J. 'Les sculptures de l'église des Carmélites de la rue Saint Jacques', *Bull. de la Soc. de l'hist. de l'art français* (1939), p. 57.

—— 'Décorations et œuvres d'art du XVIIIe siècle dans les églises de Paris', *Bull. de la Soc. de l'hist. de l'art français* (1956), 62.

VAUTHIER, G. 'Deux religieuses peintres à la Visitation de Chaillot au XVIIe siècle', *Bull. de la Soc. de l'hist. de l'art français*, nouvelle série, VIII (1916), 148.

VITRY, P. *Le Musée de Tours*. 1911.

—— *Le Musée d'Orleans*. 1922.

INDEX

Figures in bold type refer to the plates

INDEX